LECRAE

with Sharifa Stevens and Adam Thomason

SET ME FREE

POETRY AND ESSAYS

THE GOOD NEWS OF GOD'S
RELENTLESS PURSUIT

ZONDERVAN

Set Me Free

Copyright © 2025 by Lecrae

Published in Grand Rapids, Michigan, by Zondervan. Zondervan is a registered trademark of HarperCollins Christian Publishing, Inc.

Requests for information should be addressed to customercare@harpercollins.com.

Zondervan titles may be purchased in bulk for educational, business, fundraising, or sales promotional use. For information, please email SpecialMarkets@Zondervan.com.

ISBN 978-0-3104-6092-3 (hardcover)
ISBN 978-0-3104-6093-0 (audio)
ISBN 978-0-3104-6091-6 (ebook)

Unless otherwise noted, Scripture quotations are taken from the Holy Bible, New International Version®, NIV®. Copyright © 1973, 1978, 1984, 2011 by Biblica, Inc.® Used by permission of Zondervan. All rights reserved worldwide. www.zondervan.com. The "NIV" and "New International Version" are trademarks registered in the United States Patent and Trademark Office by Biblica, Inc.®

Scripture quotations marked KJV are from King James Version. Public domain.

Scripture quotations marked NKJV are from the New King James Version®. © 1982 by Thomas Nelson. Used by permission. All rights reserved.

"Church Clothes" © Reach Records. Used by permission.

Any internet addresses (websites, blogs, etc.) and telephone numbers in this book are offered as a resource. They are not intended in any way to be or imply an endorsement by Zondervan, nor does Zondervan vouch for the content of these sites and numbers for the life of this book.

All rights reserved. No part of this publication may be reproduced, stored in a retrieval system, or transmitted in any form or by any means—electronic, mechanical, photocopy, recording, or any other—except for brief quotations in printed reviews, without the prior permission of the publisher.

Cover art direction and interior photo illustrations: Tiffany Forrester
Cover photo illustration: Caleb Davis
Interior design: Emily Ghattas

Photography credits: Cover, Alex Harper; page 54-55 and 190, DC Studio/Adobe Stock; page 72, Underwood & Underwood/Library of Congress; page 96, Alan Lomax/Library of Congress; page 112-113, Нигяр Гусейнова (Nigyar Guseynova)/Adobe Stock; and page 164, Harriet Tubman: Benjamin Powelson/Library of Congress; Frederick Douglass: G. K. Warren/The New York Public Library Digital Collections.

Printed in Malaysia
25 26 27 28 29 COS 5 4 3 2 1

This book is dedicated to my grandmother, Georgia. Her journey to freedom has helped us all find freedom.

CONTENTS

INTRODUCTION ix

PART 1: CONFESSION 1

A LITTLE DIRT	2
THINKING OF YOU	12
LOVE YOUR NEIGHBOR	18
WASHED	28
GOD WOUND	34
CHURCH CLOTHES	40

PART 2: LAMENTATION 47

NO CHURCH IN A WHILE	48
GANGLAND	54
IMAGINE	64
MARTYRS	72

PART 3: RESISTANCE 81

SHUCK AND JIVE	82
MOTIVES	88
SPARE ME	94
COLIN KAEPERNICK	102
REMIND MYSELF	110

PART 4: PERSISTENCE — 117

REFLECTING THE LIGHT OF THE SUN	118
LUCKY ME	126
GROCERY SHOPPING	134
THE TOMB IS EMPTY	140
SEE YOU LATER	148
SMOKE ON MY CLOTHES	156
WE OUT HERE	164
FREEDOM	172
NOTES	182
ABOUT THE AUTHOR	189

I'm finally understanding the freedom God is giving me.

My anxiety issues are not gone.

I'm not sleeping without pills yet, and I still pop up after every five hours, every day.

But I have Jesus and He's enough. I never thought I'd feel this way. I haven't in years. I want to share His glorious gospel. I want Jesus, I want the Father. I'm aware of the Spirit's presence and I want that presence to never leave. I'm aware of my sin and shortcomings, but I'm also aware of the gift of the cross. I don't know how I drifted so far away, but I want to be forever afraid of that drift. I am refocused, fighting for contentment and joy in Jesus.

—FROM MY JOURNAL, 2023

INTRODUCTION

Freedom is in our spiritual DNA. It was the ontological plan of Yahweh for us to inhabit a lush world and take care of it and one another. In the beginning, there were no statutes or tablets of stone; no prophets' warnings, no cycles of disobedience, judgment, mercy, and deliverance. The family tree of humanity had just begun to bloom. In the beginning, there were walks with God in the cool of the day. There was no shame. Only one prohibition existed: don't eat the fruit of *that* tree.

After our ancestors ate the fruit, the strife started in body and spirit. We covered ourselves and learned to hide from one another. We learned to separate and seek our self-interest first. We quickly discovered we could fault God for outcomes we created for ourselves. We learned to blame rather than confess. We created hierarchy. We learned how to kill. We learned we would die.

Other elements added to our DNA: trauma, fear responses, epigenetic stamps of what happened to our ancestors during wars and monarchies, enslavement and assault—comingling with markers for eye color and hair texture. Our grandmothers' sorrow, our great-grandfathers' PTSD, our parents' addictions were tattooed on our strands, and our environments,

communities, and daily practices could activate or inhibit trauma in our genomes.

Freedom became a recessive gene in the kingdom of this world—a rarity.

But the truth is, freedom *is* ours. Our stories—the beautiful, the painful, the regrettable—can unearth the ways that God is at work to redeem the shackled parts of our lives, and through examining them with humility, curiosity, and most of all with the Spirit of God, we can claim the freedom that God is offering us.

I am a descendant of Adam and Eve, of enslaved people and enslavers, of freedom and bondage. My great-great-grandmother was Mandy Barnes Williams. She was enslaved. Her father was a white slave owner named Mr. Langston. Her son, John Wesley, worked in the home of the Langstons. After the Civil War, her descendants were freed. They stayed on the land. John Wesley married Alia in 1893 in Shelby County, Texas. He hauled logs and farmed to support his family and was "given" some land by the Langstons—his direct relatives, though they never admitted it.

Those are the facts but not the whole story. Assault, adoration, enslavement, abuse, emancipation, grit, and perseverance fill out the body of my

> **FREEDOM BECAME A RECESSIVE GENE IN THE KINGDOM OF THIS WORLD—A RARITY.**

bloodlines. So much of what my ancestors experienced is lost to history, but my DNA bears witness, through my frustrations, addictions, griefs. My responses to challenges in my life are my own, but also echoes of trauma that God wants to surface so they can be healed and liberated too.

But I had to want that liberation.

Jesus found me through a college ministry in Texas. I loved what I saw in Jesus—He never missed a good dinner party; He healed lepers and blind people; He gave hope and honor to Samaritans; He evicted demons—He set people free. I wanted that. I knew Jesus offered me that. "Where the Spirit of the Lord *is*, there *is* liberty."[1] In His love, I was finally free.

But I didn't live that way.

Unfortunately, I was given more chains along with Jesus, add-ons that came with the kind of Christianity I was discipled into. We—Black young people—were taught to scathingly critique Black churches for their eisegesis and paltry theology. "Good" churches had solid, academic theological stances, websites with sprawling doctrinal statements, pastors who spent hours poring over systematic theology books and commentaries, proper views on women in ministry. We mass-exodused from the faithful churches in our communities. The folks that discipled me

had me side-eyeing Martin Luther King Jr. (Never Jonathan Edwards, though.) I bought into the inferiority complex of the Black church because I was hurt by my broken home in my broken neighborhood that was full of Black churches. I wanted freedom and belonging that looked like prosperity, respectability, peace. I thought my efforts to be different—more scholarly, more theologically astute—would make me worthy. I wanted to pull myself up by my theological bootstraps.

I tucked in my shirts and pulled up my pants. I kept my hair in a neat fade. I enunciated every syllable when I was offstage. I read their books, I learned their ways. I felt like Moses, a Hebrew living among the Egyptians. Also, like Moses, I was pulled between the culture of my origin and the culture of my faith upbringing. I was constantly under a microscope; never quite good enough, but entertaining and useful. When I wore the mask, I got Pharaoh's praise. My music reflected my bondage, but I loved being embraced by the people enamored by my "exotic" delivery of their theology. I felt like I finally belonged—which made it all the more detrimental when I wasn't affirmed, when my blackness wasn't affirmed.

Terrible. It's terrible to admit this. I was chained to a lie, and I wrapped those chains around me

willingly. My ancestors fought to take off chains, and here I had gladly shackled myself.

One thing about living in Pharaoh's house, though: there's always someone reminding you that you ain't them. You still got that Hebrew accent that *others* you. You are reminded that you are a Hebrew, fortunate enough to be plucked from the rivers of ignorance and placed into Pharaoh's opulent, benevolent care—as long as you act right. But at any time, if you act "wrong," criticizing oppression, greed, or apathy for the plight of the people suffering right in front of them, they will no longer claim you as their own.

I WAS CHAINED TO A LIE.

That time came for me when I saw a fellow Black person named Trayvon Martin murdered. I spoke up and was rejected by the community I was part of. It was devastating and disorienting. I had to leave this community if I wanted my soul intact. Exodus.

The blowback I received, the violent excitement of the pile-on of people who were in my corner as long as I never spoke up about racial violence and racialized disparities in this country, sent me to

the wilderness of myself. I found myself examining everyone and everything: *Does God love me, as I am, a Black man? Who and what do I believe? What am I willing to stand for? What lies and beliefs must I tear down in order to experience freedom?*

My time in God's Word has taught me the wilderness is a faith-strengthening place and a place of testing. The wilderness is where the Hebrews waited before their deliverance into the promised land. It's the place of Jesus's testing, before calling His disciples and beginning His ministry. For me, the wilderness is where I wrestled and contemplated and confessed before stepping forward, freer. I'm not going to claim that I am living fully free—not yet. It takes a lifetime to undo the intricate bonds of the Enemy, the self, and the oppression of society—but I know that Jesus has set me free, and I wanna live in the truth of that liberation more and more each day.

> **IT TAKES A LIFETIME TO UNDO THE INTRICATE BONDS OF THE ENEMY.**

Freedom is in our DNA—it's God's intention for us, it's empowered by the Spirit, and we have access to it on this side of the fall through Jesus. If you haven't accessed the freedom that's yours, that's okay—there's hope for you inside these pages. I pray that the poetry and essays here can help you identify the hurt of your past or present or recognize the chains you were taught to wear to be godly. And if, like me, you have

mistaken Pharaoh's house for the good God who loves you, I hope this book can help you to start separating the one from the other in order to move to freedom. Let this book take you on a journey through the wilderness, sorting through your questions and relying on God and discernment to figure out where to go next.

Set Me Free contains poems and reflections—grouped by themes of confession, lamentation, resistance, and persistence—on what kept me in chains, how I am getting free, and thoughts to challenge you to reflect on your own journey, in hopes you are led to freedom. *Set Me Free* is not a map for the wandering, but insights, thoughts, and cautionary musings from my soul, to reassure you that you're not alone in your disillusionment, your anger, your worship, your questions. We are on a journey, not to freedom but to believing in the freedom that is in our DNA.

> **WE ARE ON A JOURNEY, NOT TO FREEDOM BUT TO BELIEVING IN THE FREEDOM THAT IS IN OUR DNA.**

DOES GOD LOVE ME,
AS I AM,
A BLACK MAN?

WHO AND WHAT
DO I BELIEVE?

WHAT AM I WILLING
TO STAND FOR?

WHAT LIES AND BELIEFS MUST I TEAR DOWN IN ORDER TO EXPERIENCE FREEDOM?

CONFESSION

A LITTLE DIRT

There was cocaine in
 my bloodstream.
Probably why I couldn't sleep.

I breathe death in
 and out my lungs,
praying God will help
 me rest in peace.

Hear the sound of a
 hollow heart only
beating for sin, always
 empty within.

Dark cloud on doomed soul
can't hear the cries,
 I'm keepin' 'em in.

They say obliviousness is
 bliss, huh, and truth
 brings torture.
Is all the information
 I've acquired just my
 sad misfortune?

Can anybody tell me tell me
 what's the point of living?
Are we just a bunch of
 molecules with no sins
 to be forgiven?

I guess it's dog-eat-dog,
 kill or be killed, and
 survival of the fittest now.
No creator, that means
 no purpose, no reason
 to keep livin' now.

Deep down I wanna matter,
 I want purpose to
 this shallow life.
Problem is I gotta problem
 tryna leave the darkness
 for the light.

I just wanna be happy but
 I guess I'm selfish.
I'm only hurting my family,
 hurting myself.

It really ain't no benefits
somebody hollerin
 'bout Jesus.

But I don't believe it.
Where He at? Why He
 leave me so cold
on the roof with a hand
 fulla roofies?
But ironically I'm so low.

I know He got to be
 real cuz if He not
 then why am I here?
A cosmic accident or
 just happenstance?

If so, then why do I care?

If it ain't no God, then
 it ain't no good.
If it ain't no good,
tell me why this
 agony is so bad?

Playing Russian roulette
 with my life after death—
please stop me.
Cuz I don't really
 wanna do that.

I just wanna end the
 damage that I feel.

What's my purpose?
How can I heal?

I put my trust in life
instead of trusting Christ.

I'm sure that's how
 I got here,

but I feel like I
 can't turn back.

Sittin' here with my life in
 my lap, close my eyes and
 I'm on the other side.
Is it heaven, is it hell,
should I take that chance?

Dear God, Imma open up—
I'm feelin' lonely.
I don't know if Imma
 make it but I'm
fighting back slowly.

Lemme get this here straight:
You already laid Your
 life down.

You already gave Yours up
so I ain't gotta
 take mine now.

You walked to Your death—
wasn't quick, wasn't painless.

Everybody pointing
 fingers, but You the
 only one blameless.
It's like I see You looking
 at me with my name

 written in Your blood,
and You died so that
 I can live
and You did it all outta love.

I was bought with a price.
If I take my life then
 I waste my life.

And next one's better.
Imma face this whether every
 day feels good or I hate
 the stormy weather.

I know You made me
 for some reason.
I'm more than flesh and
 blood breathin'.

I pray to God for the faith
 to believe that in Jesus
 I can find freedom.
I need Him.

I was made in Ya image,
and You gave me no limits.

If I love this world
 then I hate my life.
I mean who's to say that
 He's the one that
 I should run to?
Aww, who am I kidding?
I know it's true,
 but I don't want to.

I run to it,
 I run through living fluid,
ain't nuthin to it.
Just listen to me.
Let the water wash the
 blood off of our hands.
Let it affirm that I mean
 what I'm sayin',
what I mean when I'm sayin'
I'm sinning.

Stuck in these chains
 when I re-emerge,
I'm coming up saved
symbolizing my change.

Chains hang on my tired,
 blood-stained hands,
hangin' on by a small strain.

Mental mind frame
 stressed out,
they tell me I'm blessed now
in heavenly places, but
 here on earth it's
 just sweat now,
tears now, death now.

I run to the river,
no regrets,
drown me in forgiveness,
 all I confess.

I run to the river where
 dark becomes light and
 the sick get delivered.
I run to the water that
 can wash away tears
 of our daughters.

I run to it—suffering,
 sick, and enslaved.
Dip me in, symbolizing
 my change.
I pray it wash the
 blood off my hands.
I pray heal the heart
 of this man.

Endured pure evil,
deceitful people,
I'm weak and feeble.

I've been swimming upstream
 tryna fight for freedom,
but now I drown down in the
 Jordan River of redemption.

Water of new mornings.
Swimming in new mercy.

No more dying of thirst.
This water works.
I'm in feet first,
heal my hurts.
Bloodiest crime is
 like a lil dirt.
Let the water wash
 away the curse.

Sometimes we can feel buried alive by the dirt we've done and the dirt done to us. Heavy memories that creep into our consciousness and sit on our chests, meaning to suffocate, filling our minds with doubt and dread.

Can you name the dirt you've done? The dirt done to you? I've talked about my most shameful moments before, but believe me, it doesn't necessarily get easier. I remember asking for my unborn baby to be aborted, disregarding the implications of my request beyond how it would affect me. No thought to the young woman carrying my child or how her body and her emotional health would be affected. No thought to the baby growing within her.

It still feels like sucking in soil for air sometimes, thinking about their bodies and my choice. I wonder what effect I would have had if I had been more observant and gentle, more honest with my fear. If I had centered her rather than myself.

How can God forgive me?

Yet God *has* forgiven me. God be praised, I have encountered the living water of Christ, and He has done the impossible—He has cleansed me. First John 1:9 holds a mind-boggling truth that God forgives and cleanses us when we confess our sins. He's faithful in a powerful way.

God's love is a rushing stream, a flowing river of life. God's forgiveness is so formidable and all-encompassing that it smooths stony hearts to flesh and makes flesh out of dirt.

Sometimes I need a reminder that I am in God's hands, and that nobody and nothing, not even me, can pluck me out. Maybe you need this reminder too. I need to remember that God will go to the deepest places to find me and rescue me and will not pass out from the darkness and lack of air. Even if we make our bed in Sheol,[2] the Lord will be with us; this is the endurance, stubbornness, and beauty of God's love. Our sins are not dirty enough to hold up against the cleansing power of God. That living water is miraculous.

Confession is an important part of experiencing freedom in Christ. We can't be free if we stay chained to the dirt that suffocates us. Toni Morrison put it in earthier tones when she wrote in *Song of Solomon*, "Wanna fly, you got to give up the $*!t that weighs you down."[3] Confession is a declaration of wrongdoing; it is humbling and specific. I am not speaking of the shallow non-apologies tossed out for the sake of image and public relations, devoid of sincerity. I mean naming our sin, not for human approval but because we know that we will suffocate ourselves and others if

> **WE CAN'T BE FREE IF WE STAY CHAINED TO THE DIRT THAT SUF-FOCATES US.**

GOD'S LOVE IS A

RUSHING STREAM,

A FLOWING RIVER

OF LIFE.

we don't take the thing to God. We beg God to hear, to have mercy, to forgive, to empower us to make amends, and to wash away our dirt with living water.

I have had the privilege of learning the Messianic Jewish perspective of living water. Living water is water that only God can make—rain, oceans, streams, rivers—not touched or fabricated by humankind. Living water comes in its natural state and remains in it. Living water is used to cleanse in many ways, most notably in the Judeo-Christian faith, through *mikvahs* (immaculately structured pools of living water gathered from rains or even snow and ice, used for ritual cleansing) and baptism. John the Baptist used the living water of the Jordan River to offer the baptism of repentance after the confession of sins.[4] This river is also where, in the Old Testament, the Gentile Naaman was directed by the prophet Elisha to dip to be healed from leprosy.[5]

In John 4, when Jesus approached the woman at the well, Jesus called *Himself* the Living Water. This woman, by the standards of the day, might have had a "lil dirt" on her. She was a Samaritan—disliked by the Jewish communities—and five men had divorced her. And yet Jesus went up to *her* and offered her the promise that if she followed Him, she would never thirst again.

So what did Jesus mean when He said that He was Living Water? He was telling this woman that He came there not to shame her but to cleanse her and to offer her life. Jesus came to cleanse the repentant. He came to cleanse the stigma of trauma, neglect, the shame layered on her, and the bigotry she experienced.

Like the woman at the well, many of us know what it feels like to buried alive by the dirt of our circumstances and poor choices. But the good news is that the living water remains, ready to cleanse you with forgiveness and reveal to you who God is.

BUT THE GOOD NEWS IS THAT THE LIVING WATER REMAINS.

Where are you hopeless? Where are you burdened? Where are you suffering? Where are you chained to your sins?

You thirsty? Jesus offers living water, and the dirt on you is nothing compared to the deluge of cleansing He offers. It does not matter how dirty you see yourself. The Living Water—Christ—cleanses *a lil dirt.*

THINKING OF YOU

Woke up this morning you on my mind.
I think about you all the time,
 this should be a crime.
I'm so consumed with everything
 that you do,
every word that you say. I'm watching your
 every move.
It's cool to be concerned and cautious,
but I am so obsessed it should be makin' me
 nauseous.
You know that I'm watching
but I know you like it.
I'm feeding ur ego,
 it gets me excited.
I probably do anything for you outside of my
 right mind
even when I hate you.
I'm dreamin' of you in the nighttime,
I be checking ur timeline daily,
thinking 'bout what you be saying,
embarrassed at your mistakes
but rarely hear me debating.
I support you to the end
even when
I don't fully comprehend why you would do
 what you did.
I know I'm over the top, need to stop,
and I'm fighting it daily plus I know u right
 here listening and thinkin' I'm crazy.

All I seem to think about is you.

You you you all in mind every hour, every minute,
 every second of time.
I try to be not so consumed cuz it's bad for my health.
What kinda clothes you be wearin',
how you treatin' yourself.
Some of it I understand but most of it is a curse.
U told me plenty of times to let it go but it hurts.
I mean what would you be without me?
I'm thinkin 'bout you,
you thinkin about me.
Forget about the others,
they only gon' mess
 up my plan
to be focused on you alone.
Man, what am I sayin'
givin' you all my attention?
Nutso.
I fill you full of pride,
got you thinkin you much mo
than you really are.
You are not a star,
you deserve nothin',
and everything you got is a gift so stop frontin'.
I'm buggin'.
Lord knows I'm askin' for help.
Once again the person that I'm talkin 'bout is myself.

Focusing on the self is a very popular topic in the West right now: self-help, self-care, and self-love crop up in popular books, social media, education, and entertainment. Folks are zealous about guarding their "me-time." I am here for a lot of the self-care focus. I get happy every time I see my sisters encouraging each other to rest, hydrate, and cultivate habits of tenderness toward themselves. The trope of the "strong Black woman"—this unspoken pressure to never show any weakness—has robbed so many of my sisters of vulnerability, rest, restoration, and, really, the expression of their full humanity. I applaud the things that get them rest.

Similarly, it's wonderful to see my brothers openly talking about the benefits of therapy. So many of us equate manhood with "toughness." In the pursuit of appearing masculine, we have denied ourselves from expressing any emotions beyond anger, humor, and desire. Many of us have also been shamed into believing that our trauma and depression are evidences of a lack of faith, rather than a result of harm and biochemistry. Meds and therapy can certainly help to heal generational afflictions. I am a strong advocate for the liberation that comes from tearing down the strongholds of trauma.

So hear me: I am not downing self-care or the

> **I APPLAUD THE THINGS THAT GET THEM REST.**

pursuit of wholeness and peace with the self. We should all know, love, and honor ourselves.

However, there's a difference between self-love and self-obsession.

It's important in our journey to freedom to become self-aware of our thoughts and emotions, to be able to sense what hurts and discover what heals. We cannot live like free people if we don't know ourselves. Humble and accurate knowledge of our limitations, strengths, joys, fears, and whom we worship and why forms good boundaries for us. This knowledge helps us to filter nonsense, gaslighting, and lies we tell ourselves, and it also provides a signal for when we need help, redirection, a nap, or some grub.

But these days, we're prone to self-obsession. Our purpose in this world is about so much more than our individual success, but we aren't being sold that message. Technology makes it easier than ever to be self-absorbed: we can work from home, shop from home, and post pictures, videos, and opinions of ourselves. We even have tools to curate our own reality by muting and blocking and turning the channel. We believe the illusion that we are an island unto ourselves.

We have a lot of wisdom to gain by looking outside of ourselves. We know God and know ourselves

THERE'S A DIFFERENCE BETWEEN SELF-LOVE AND SELF-OBSESSION.

through community, not isolation. How do we truly know we are growing in patience, generosity, and empathy if we're alone? The first man spent some time as the only human in a sin-free world—no sin at all!—and God *still* said, "Yeah . . . this is not good," and created community by creating the first woman. We're not meant to be alone, and I don't mean this solely in a romantic way. We were created to commune, and this is one way we reflect a triune God: one God, three persons in perfect, perpetual communion. The vision of the new heaven and earth is thoroughly communal. We gonna be together. We are practicing for forever.

THE VISION OF THE NEW HEAVEN AND EARTH IS THOROUGHLY COMMUNAL.

We set ourselves up for the unexpected bondage of self-absorption when we don't surround ourselves with trusted loved ones. Especially with my increased visibility, I have to be intentional to stay grounded by spending my time with my friends and loved ones,

who care more about me as a person than my accolades. It would be easy to instead surround myself with people who say only what I want to hear, but not as edifying in the long run. The choice is always before me, so I have to constantly exercise wisdom in whether I choose growth or ego.

How do we balance a healthy view of self and yet remain free from self-obsession? How can we escape from that egotistical monologue we have rolling around in our heads all day and night? I'd encourage you to be like Jesus and meet some people face to face. Jesus had a way of getting to know people who passed Him in the street, mostly people who weren't like Him. We can't live alone, just like we cannot be born alone. Life, for better or worse, is a group project.

LOVE YOUR NEIGHBOR

Love your neighbor as yourself but you hate your reflection
cuz I see you in them, in her and him.

You stopped loving you but you love the way money can
 hide you.
Designer glasses cover eyes that been dying to find you.
Can't see yourself cuz you see the way they took your love
 for granted.

Love on the shelf,
why should you give out what was never handed?
Just know Sephora won't cover hurt.
That mani got you lookin' pretty,
we know it never works.

I'm sorry for the pain somebody caused you
and what it cost you,
how that childhood trauma lost you
and no one sought you.
You don't have to get your angles and your filters together
loving you for who you are is better.

Love yourself,
all you do is judge yourself.
You can't really be you if you busy being someone else.
Love yourself.

I'm you and you are me,
likeness and His image on colored skin and crooked teeth
Jesus loved a Judas.

You can love a fallen saint.
David did his dirt.
Moses killin' like he Cain.
All of them conspired,
still retired in the hall of faith.
Samson let desire burn his eyes but felt the call of grace.

So why are we lying masking our true desires?
They don't really love you, they just love to see you dying,
love the way you crop and filter,
manicure your picture.
You don't love yourself if you can't see love from Scripture.

Struggling to be yourself and tell 'em what you feelin',
when you ride the fence a part of you is still in prison.

They love all your quotes and sayings but not how you really feeling.
You cover your real emotions
and manicure petty flaws.
You pray for someone to love you but don't love yourself at all.

My cousin gay, my homie Muslim,
seen how people judge 'em.
We all got different lives
but they know I love 'em.

Just like I love my nieces,
want 'em both to know that they don't need men to be completed.

I got my own convictions,
Afflictions.

I know I'm different.
They mock me for me being Christian
or not being efficient.
My hair too nappy,
my clothes too fancy.
I'm too religious,
either that or I lost my mission
chasing chart positions.

Love your neighbor as yourself but you don't do the latter.
It's hard to love yourself when people tell you don't matter
cuz I see you in them, in her and him.
I think you get the pattern.

I don't do religion to fit in the diatribe,
but I gotta be who I'm s'posed to be, not who they decide.

Who love you like Christians love Kanye's new conversion,
who love you when you look in the mirror and daily lack
 discernment.

When I first moved to Atlanta, I led a small group at my church. This particular woman, Simone,[6] joined the group.

Imma keep it real: I rocked with Simone in a surfacy, all-small-group-members-matter kind of way, but I rolled my eyes on the inside every time she showed up. She was too wrapped up in the pursuit of perfection. Simone's hair laid bone-straight, not a hair out of place. Her clothes were peak pick-me conservative. She always knew where to find just the right Bible verse to suit her point. What bothered me most, though, was that it seemed like she was constantly telling herself or somebody else how to earn God's love.

Now, I look back at the times I judged Simone so harshly and shake my head. Simone was not just wrapped up in pursuing perfection; she was trapped—and for too long. I wasn't curious enough to investigate why. Hasty judgment is the antithesis of the way of Jesus. He was masterful at asking evocative, thoughtful questions and engaging with the answers He was given—responding to both what was and wasn't said. Jesus's command of emotional intelligence, context, and compassion allowed Him to delve deeper into who people really were—way more than shallow niceness ever could. He lavished people with time and demonstrated genuine curiosity, because He loved well.

And here I thought I knew who Simone was based on her bob. Maybe you think you know who someone is based on their hair too—or their clothes, bank account, age, skin color, gender, or their body's abilities. But that's lazy, right? It takes no work to judge without genuine engagement. It's impossible for us to love our neighbors well without curiosity.

We're telling on ourselves—how we view God, the world, and ourselves—by the way we love. If we're struggling to love our neighbors, that's a strong indication that insecurity and self-hatred are taking root in our hearts. The Enemy's tactic is to put limits on love, to convince us that we only have so much, and that we can't possibly view *every* human with the same value, dignity, and worth as we view our own families. This kind of love scarcity separates and segregates: the people who don't deserve my love versus the people who do; the people who I am willing to exploit, ignore, or condemn versus the people who share interests with me; the throwaway people who have nothing to offer me versus the people I pay special attention to because they have something that I want.

Here's what was really going on with Simone: She struggled hard to live up to an impossible beauty standard of womanhood in a world hostile to Black features. She strove to conjure Black Girl

IT TAKES NO WORK TO JUDGE WITHOUT GENUINE ENGAGEMENT.

IT'S IMPOSSIBLE FOR US TO LOVE OUR NEIGHBORS WELL WITHOUT CURIOSITY.

Magic—professional perfection and seemingly effortless success—when she needed support. And Simone denied her attraction to other women in order to continue being accepted in the church, one of her primary places of community. She was performing perfection in an effort to feel safe. She didn't think God or anyone else would love her if she was just herself. (She's not wrong to have feared this—many of us put conditions on our love for others that Jesus doesn't.)

SHE WAS PERFORMING PERFECTION IN AN EFFORT TO FEEL SAFE.

Simone exhausted herself trying to keep up appearances for the sake of acceptance. She had a crisis of faith, understandably. She left the church, shaved her head, and admitted she was into women. She collapsed into her reality, and it undid her "perfect" world.

I didn't want her to feel alone. I called her and said, "Nah, I'm taking you to lunch." We sat down and finally had a conversation. I humbly asked curious questions with no agenda. Simone was so gracious. I said, "Yo, can I have freedom to just, like, ask questions? I'm

just an ignorant child. And I, just, I don't know what I don't know. So can you have grace with me as I ask you things?" She obliged me (and listen, reader: she didn't need to at all). Simone, with her patience and openness, taught me how to be a good neighbor to her. Simone shared with me that she experienced the love of God during the depth of her struggle, and that is what freed her. Not our approval. Not her hiding.

That's my girl now.

If I got a do-over when Simone first walked in, I hope I would throw out judgment in favor of curiosity. I hope I would take time to recognize how her perfectionism hid her fear of being known. I hope I would assure her that God loves her so much and would be with her wherever she is, and that God would never ask her to earn His love. I would love her because she reflects the image of God. I would honor her transparency. These days, she's trying to figure out how to love God in the midst of her queerness, legalism, and womanhood, and our group is committed to walking with her—as a friend and not a project.

It takes curiosity but also a whole lot of humility to neighbor well. For example, as a Black man, I've seen my white brothers and sisters distance themselves because they were too scared to say the wrong thing. But the most impactful people have said to me, "I don't

know what I don't know, but I want to be in a relationship with you, and I am willing to learn." We need to extend that humble willingness to our neighbors.

Love was demonstrated to us through incarnation, not segregation. The way of Jesus makes the world into a neighborhood, and everyone a neighbor. That can be intimidating, a neighborhood with seven billion neighbors, especially if we grew up in a society that thrives on both voluntary and enforced segregation, gated communities and ghettoes.

But the way of love is better. The way of love is freeing. To love yourself is to free yourself. To love your neighbor is to free them too.

Think over your life: Was there a time when you felt unlovable and yet you were loved well? What impact did that have on your heart and your circumstances?

And finally, when you consider your neighbor, do you picture someone who is just like you? I'd challenge you to consider someone whose lifestyle is one you can't imagine living—one you may even condemn. The greatest commandments still stand, beloved: love God with your everything, and love your neighbor as yourself.

TO LOVE YOUR NEIGHBOR IS TO FREE THEM TOO.

WASHED _ WASHLESSNESS. / WIPE POWER. / DROWN FORGIVENESS. / I SLAVERY; / NOW I'M DOM. / SEAS OF NEATH THE SURFACE MY LIES… / EVEN AM NEVER WASHED,

AWAY MY WORTH-
AWAY MY WILL-
MY SECRETS IN
WAS SWIMMING IN
FLOATING IN FREE-
SADNESS DEEP BE-
/ UNDERWATER LIES
IF I AM WASHED, I
BECAUSE I AM WASHED.

I'm not Moses—let's get that out of the way. But I find camaraderie in his story written in the book of Exodus. Before he had any idea of the significance, water wound its way through Moses's life; even his name—"Drawn out"—was a reference to water. He floated on the waters of the Nile that swallowed so many Hebrew infants in a baptism of death. He didn't sink but was saved because of the will of God through the compassion of women who intervened to preserve his life. They wanted deliverance for him before he even knew what freedom was.

My grandmother wanted mine. She was a devout Holiness Christian. She became a believer in her forties, after raising my mom and aunts and uncles. My mom knew a whole other woman than the granny who watched over me and took me in every summer. One of those summers—I must have been four years old at the time—Granny took me to the Pacific Ocean. We waded into that frigid water, and she dunked me in it. I came back up, shivering and wide-eyed, to my grandmother's grin and smiling eyes. I had no idea what was going on. Didn't even really have a concept of Jesus. I know now that Granny drew me out of the waters as a dedication. She wanted me to float where others had sunk.

Water signifies so much in the Black experience

> **SHE WANTED ME TO FLOAT WHERE OTHERS HAD SUNK.**

in the United States: the Atlantic cradles the remains of people kidnapped from the shores of Africa, then drowned—by choice, by disease, or by starvation—before arriving to the Americas. The oceans separate us from a homeland we were deprived of knowing. Yet we still find joy in the baptismal waters. For American Descendants of Slavery (ADOS) especially, the purity and holiness of baptism—the wearing of bright white robes, the gathering at the river, the ecstatic celebration—was one ritual free from the dirt of racist propaganda.

To be baptized was to be more fully ourselves, aligned with and loved by God, and unstained by the hatred smeared onto us. We have affirmed, throughout the years, that we are Black and we are clean, pushing back the false narrative of our perennial dirtiness. God made us, and therefore we are good. Jesus died and lives again, and we believe, so we declare it by entering the water, symbolizing our death in Christ, and are lifted out, rising in Christ. The waters of baptism symbolize an identity and citizenship shift. Water is a part of our spiritual heritage through baptism. We go down as sinners, die with Messiah, and reemerge from the waters, washed.

I became a believer when I was in college, but I hadn't yet gotten baptized. I participated in a ministry

TO BE BAPTIZED WAS TO BE MORE FULLY OURSELVES.

called Impact. The campus leader looked around at all these young people, many of us unchurched, wanting to follow Jesus, and decided to have a baptismal service. So, we gathered at Moore Street Baptist Church in Denton, Texas, lined up in our white robes, and the man who discipled me, Dhati Lewis, dunked me in the baptismal tub. This water was warmer than the Pacific. This time I went in the water with eyes wide open: I was physically demonstrating what had already happened to me in the spiritual realm. I died to self and was resurrected in Christ, a new person.

The water is a witness to all that we've been drawn out of our depravity, our pride, our selfishness, our violence, our lies; and also the abuse we endured, the things and people that threatened to break us. To be washed is to be drawn out of the water, whether to rescue (like Moses) or to mere survival (as in the Middle Passage[7]).

Maybe you're skittish about wading into the waters of baptism, because you have been used, deceived, or condemned by the church. When the water has been wielded against you, it's hard to wade in. I understand. When the people who claim Jesus also bring chains and a heavy yoke, it feels safer to stay at a distance. Some of our ancestors were trapped by slander, slavery, and sexualization and were not given

> **I DIED TO SELF AND WAS RESURRECTED IN CHRIST.**

the breathing room to express their full humanity. They were sold a false gospel—one that dehumanized them and kept them in chains—all in the name of Jesus. But despite the abuse of slavery, God offered my ancestors true freedom, in the personhood of Jesus, and they took it. They chose to wade into the Living Water, where any manmade shame was washed away.

You are a child made in the image of God, and your image—your dignity—is untouchable. Each and every one of us—and yes, hear me, your Black body and soul—has been offered Living Water. So I don't care what other kind of water they try to pour over your life. It might sting, but it's not gonna take you down, because you're alive in Christ, and that beats everything. Claim your freedom. Swim in it.

How can you wade into the waters of Jesus a little more day by day? I'm not asking you to lean into the waters where you've been hurt or abused. Just Jesus's living water. The kind of cleansing He offers throughout the Bible, the kind of cleansing He's poured over my life—He wants to pour that water over you. Come and float in freedom, and then go and bring others.

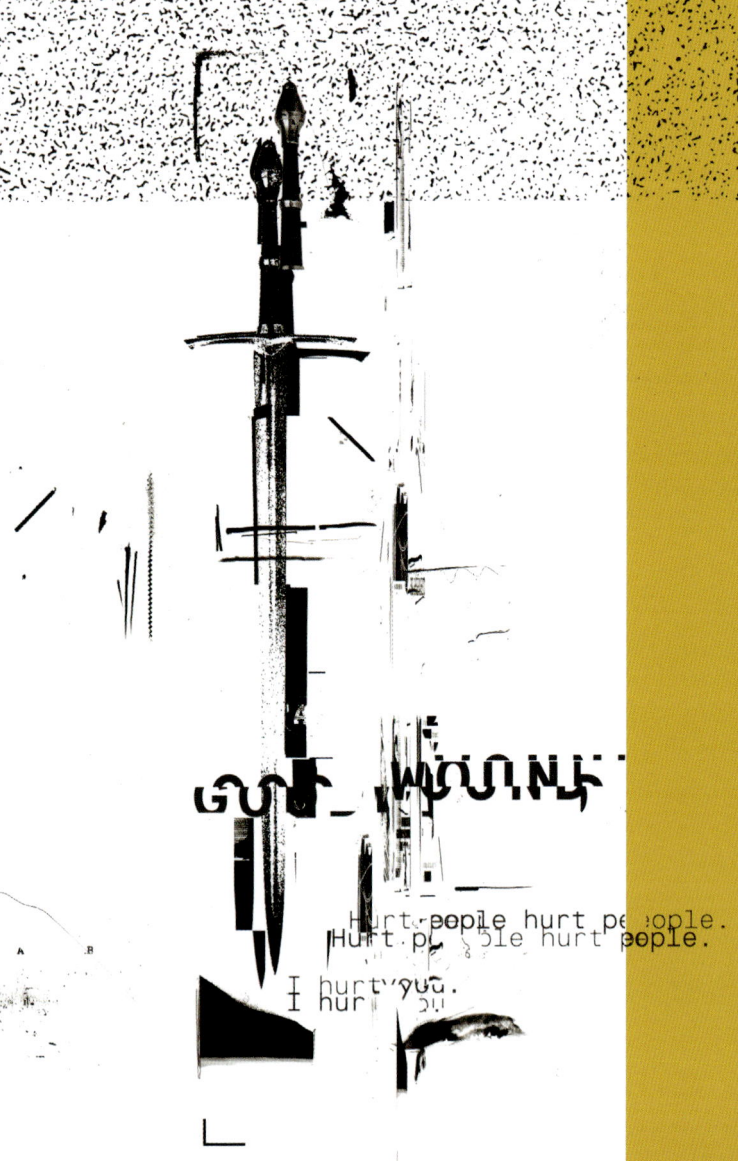

GOD WOUND

IT'S HARD TO COME TO GRIPS WITH IT.
ON MY BEST DAY I WAS FIGHTING TO FOLLOW AND GROW,

BUT ON MY WORST, I WAS HURTING AND RESOLVING TO GO,

THROWN AWAY GHETTO BLACK KID I FELT EVANGELICALS
NEVER WANTED.

I WAS REBELLING. I WAS RELIVING.
I WAS REVILING. I WAS REVERTING.
I WAS SELFISH AND DIDN'T CONSIDER WHAT MY HURT
WOULD CAUSE ME.
HURT PEOPLE HURT PEOPLE. I HURT YOU.

WHEN I SOBERED UP I SAW THE MESS I MADE,
THE PAIN I GAVE.
I WAS MAD AT THEM NOT YOU.

I MADE MY PEOPLE WOUNDS...GOD WOUNDS.
I NEED TO FEEL THIS PAIN TO KNOW THAT
I NEVER WANT TO HURT YOU LIKE THIS AGAIN.

In 2018 I knelt in my closet to read and pray—not out of some sort of piety, because I definitely didn't have a "war room"–type prayer closet. I was desperate for an inner quiet so I could hear something—anything—from God. I hid in the dark. I felt undefined. I prayed but didn't expect an answer; I didn't think God would have anything to do with me. But then I opened my Bible . . . and wept. I knew God was real in that moment, and personal, and loving—because the story that opened in front of me? It was a loving embrace.

But let me share the wounds first.

Touring can bring out the best or the worst in you. Tours will tell the truth about what you believe, through your intention and habits. You wanna stay hydrated on tour? You gonna take that bottled water with you wherever you go. You wanna stay in shape? You gon' hit those weights and run. But also: you wanna hit that party? You can. You wanna get wasted night after night? You can.

I was on tour and riding a wave of popularity, benefiting from all that flows from celebrity. At the exact same time, I had plummeted from grace in evangelical circles: my hair and my sound displeased them. I had made the dangerous mistake of equating white American evangelicalism with God and hadn't

yet untethered Yahweh from white men's voices. I was in a lot of pain from their rejection. I treated friends coldly. People would ask for help and I would withhold it. I made some terrible choices.

I MADE SOME TERRIBLE CHOICES.

When the pain is too sharp, anesthesia feels so good because it feels like nothing; you can't feel what's cutting you. Over time, you need more and more of the same numbing agent to feel a fraction of that nothingness. Both the warning signal of pain and the numbing effect of anesthesia are dulled to your senses—it becomes less and less possible to know which pain is a product of growth and which is a consequence.

And so it was that I was downing my eighth shot in New York City on Halloween night when I should have taken my behind to the hotel to get some sleep. I was wrestling folks in the street, talking crazy, popping benzos. And so it was that I was nodding my head at the brother touring with me, as he was slowly grinding on somebody on the dance floor. I went to bed drunk. I woke up with a massive hangover and a clinging case of clinical depression.

My wife, Darragh, didn't know any of this; she just knew I wasn't following the Lord. I told her everything. She was rightfully horrified. Confession poured out of me: my fear of being a failure as a father, my desire to be out on the road, my disappointment in God's people, my distrust for them. I called the man I considered my pastor and confessed to him as well. The confessions were oddly cathartic, unburdening me from the weight of shame I'd hidden away. My pastor said, "The good news is, there's nowhere to go but up." He was right, but I still felt unsettled—I received such love, such grace, and made plans to move forward with my wonderful wife. *But what about God? What would God do? How would God respond, if at all?*

But then that day in 2018, huddled in my closet, my Bible opened to the resurrected Jesus meeting Peter on the banks of the sea and restoring him, saying, "Feed My lambs."[8] Three times. Covering every denial with forgiveness and commissioning.

I knew all about Peter denying Christ three times. I imagine Peter seeing Jesus stare right through him, aware that he had denied his friend, his Lord. And then his friend, his Lord, was murdered. There would be no reconciling, no apologies. I imagine Peter carrying that weight of guilt along with the trauma of his

friend's death. He couldn't do anything but what he used to know—so he went fishing, to the comfort of the familiar. And maybe he was returning to the place where he remembered encountering Jesus for the first time. Curled up in my closet, I understood that grief.

And also, the unfathomable love and redemption. I was in bondage to addiction, angry at everybody, so wounded. God didn't wait for me to get my act together before He met me in that closet. And I didn't magically get myself together because of that encounter—but I discovered something then that wouldn't leave me: I was deeply, personally loved by God. And His love was a salve for my wounds.

The decision to trust God leads to a type of freedom. I don't mean trusting in a generic, shallow way. I mean trusting God wholeheartedly to keep us in God's love as we honestly express our anger with God's inaction, lament that God hasn't moved in a certain way, and ask God to show up in a way we can feel.

Feel your wounds. Express them honestly. God is not too busy to care, and God is not too impersonal to notice.

FEEL YOUR WOUNDS. EXPRESS THEM HONESTLY.

CHURCH CLOTHES

RIP to Medgar Evers, RIP to Dr. King.
I ain't tryna hate on my own kind but
Al and Jesse don't speak for me.

Probably gon catch some flack, man,
Imma swallow this pill like PAC-man.

Some of these folk won't tell truth,
too busy tryna get them racks, man.

Church tryna rob my paychex,
choir members probably havin' gay sex.

Pastor manipulatin, hurtin' women,
wonder who he's gon' slay next.

Bookstore pimpin' them hope books
like God don't know how broke looks,
tellin' me I'm gon reap a mill
if I sow into these low crooks.

Plus I know ole girl a freak how she singing solo.
I walked in the church with snap back
and they tellin' me that's a no no.

That's backwards
and I lack words
or these actors
called pastors.

All these folks is hypocrites, that's why I ain't at church.
Truthfully I'm just me
and I don't want to face no scrutiny.

As long as church keep wildin' out
I can justify my foolish deeds.

Smokin' weed pourin' up
keep that lean up in my cup.
Maybe I could change the world
but this porn on my laptop got me stuck.

Yeah I know what's right from wrong
that there ain't gon sell song.
Rather sell my soul than save it
if that's what make my money long.

Better not be a real God
with real hope
that heals hearts
shows me I ain't livin' up to everything
He put me here for.

Better not be no real church with real saints
who pray hard
Imma just rock that snap back
501s with Js on.
Better not be no real folks
who don't think that they better than you
straight or gay
drunk or high
they walk through the cold weather with you.

Nah we don't wanna see that
cuz that might mean a life change,
cuz that might mean I'm worth more
than money cars sex and pipe dreams.

Better not be no real Jesus
real forgiveness
for hurt folks
If God's gon take me as I am
I guess I already got on my church clothes.

I cannot think of another verse I wrote that's more polarizing than "Church Clothes"—and I can see why. I remember writing these lyrics because I wanted to shake up the industry. Now I have a fuller understanding of what I was rhyming about then.

I wrote "Church Clothes" from the perspective of an unchurched person who's frustrated not with God but with church hypocrisy. Basically, the tone is "How you gon condemn people living one way on the outside, when you turn a blind eye to what's going on within the church walls?"

But let me start with an apology. Many folks remember the line about choir members. I did want people to clutch their pearls at that line. But I now realize that I was referencing flesh-and-blood people who are on the receiving end of a lot of hatred and are routinely excluded from so many Christian spaces. I should never punch down by using marginalized people as punchlines, especially not a group of people with elevated risk for suicidal ideation, discrimination, family rejection, and violence. I am sorry.

Part of my getting free is looking squarely at the ways I pursue freedom for myself at the cost of other people. Now I know that some of you will want to debate me right away about whether I am affirming

or what I think about the LGBTQIA+ community, to attempt to put me in an ideological box. I am not doing boxes anymore; I am doing nuance and love. My goal is to live up to the standard Jesus set for us when He said that the greatest commandments are to love God with our everything and to love our neighbor as ourselves. Every neighbor.

I AM NOT DOING BOXES ANYMORE; I AM DOING NUANCE AND LOVE.

I wrote "Church Clothes" as a kind of catharsis and self-critique, because like it or not, I am part of the church. It's a reminder to shed the condemnation and judgment that can be so prevalent in the church, and instead remember that each one of us is priceless and also a mess. We grow in Christ together, and we carry each other's burdens with honor, flaws and all. That's how we grow and worship in spirit and truth instead of legalism and hypocrisy.

"Church clothes" in our community can be a beautiful thing. Our formal dress is an expression of our honor to God. It is also true that our Black churches historically functioned as one of the few

places where we would be treated with dignity and have the power to worship freely. It's natural that we would dress the part.

Yet now, church clothes can be symbolic of a façade—clothes that we wear to please Granny or to appear holy, but that we would never wear Monday through Saturday. God's never been one to merely look at outward appearances—God is always checking out our hearts. It's not surprising to the One who created us from soil that we can be dusty. Why try to hide from God? God sees the dirt already. God works with dirt. God will not leave offended because of our honesty. While we are yet sinners, Jesus is loving us, the Spirit is beckoning us, and the Father is inviting us to come home.

Façades and freedom in Christ do not go together. Jesus didn't require any outward prerequisites before He forgave and healed His followers. Jesus went right to the places where the people who needed Him were—boats, the temple, dinner parties, the well—and asked them to follow. When the unpopular tax collector Zacchaeus hid in a tree to hear Jesus's teachings, Jesus invited Himself to Zacchaeus's house. Jesus stopped to heal the woman in the crowd with the twelve-year hemorrhage, even though her very presence went against purity laws of the time. Jesus didn't

say, "Sorry, too late," to the thief on the cross next to Him when he expressed remorse. He doesn't require people to clean up, change clothes or occupations or relationships, and *then* follow. People were free then, and we are free now to come as we are.

When we make the church a place where there are prerequisites and a uniform, we lose the power of God to work through us as a community in faith and love. We've made church a nice theater to play at pretend holiness, but the liberty that the Spirit gives is more inviting, welcoming, and comprehensive than many of us understand. The Spirit frees us from trying to fix people—because that's the Spirit's job. The Spirit frees us from playing dress-up, because we dress in spirit and in truth.

If someone makes it into our doors after wallowing in a pigpen of awful circumstances or rebellion, we dress them with love and we prepare a place for them. We feed them. We remind them that they are priceless to the Father, and that He is welcoming them home.

What if we took off the façade of what we think a good Christian is and freely embraced one another where we are in the journey?

> **WE'VE MADE CHURCH A NICE THEATER TO PLAY AT PRETEND HOLINESS.**

PART 2

LAMENTATION

NO CHURCH IN A WHILE _ NO CHURCH YOUR CHILD. / I'M PANDEMIC-ED TO SO FOUL. / I WAS TRYNA HELP MY MINUTE, BUT YOUR PEOPLE CALLED NOT TO LISTEN. / I THOUGHT WE KIN / DEEPER THAN OUR SKIN. / I BY IT FOR OUR DEEPEST SINS. / A MIN / PARTIALLY BECAUSE I'M LET ME IN. / I BE FEELING LIKE THEY MY WORDS UP TO BAIT ME / AND I THAT'S DRIVING ME CRAZY. / BUT IF PASSIONATE 'BOUT MY PEACE. / BUT SOME OF IT RESIDE WIT' ME. / TORAH CLUB OR A CHURCH. / AFTER IF I NEVER SEARCH, / BUT I NEED / HOPEFULLY WE FIND CONSENSUS

IN A WHILE. / GOD PLEASE HELP OUT
MY LIMITS / AND THEY TREATING ME
PEOPLE, / FELT LIKE MOSES FOR A
ME FAKE AND TOLD THEY CHILDREN
WAS FAMILY / I THOUGHT WE WAS
THOUGHT WE WAS BLOOD COVERED
I AIN'T BEEN TO CHURCH IN QUITE
NERVOUS THAT THESE FOLKS WON'T
HATE ME AND LATELY THEY TWIST
TRY TO DISPEL THE RUMORS BUT ALL
I'M HONEST IT'S SOME PASTORS WHO
BE WANTING TO BLAME THE CHURCH
NOW I'M FINALLY OPEN TO TRY IT, / A
QUARANTINE I WAS LIKE MAN I'M GOOD
THE PEOPLE LIKE I NEED MY SENSES.
AND WE COME TO OUR SENSES.

A year or two before the pandemic, I hadn't been to church in a while, on purpose. We literally fled to Egypt because I didn't trust God. I had been discipled into a version of Christianity dominated by white apologists who had rejected my assertion that Trayvon Martin's Black life mattered; that Mike Brown's Black life mattered; that my life would still matter if I never remixed another bit of reformed theology. I couldn't pick up the Bible—I would hear Tommy Nelson's voice as I read Romans. My friend Sho Baraka asked me to name a single Black theologian. I couldn't. I had been thoroughly discipled into white evangelical Christianity—I allowed it for the acceptance I craved. But now? I couldn't try to listen for God without hearing a white man's voice. So I fled.

In Egypt guides pointed out the witness of Exodus without ever having read the Pentateuch, telling us about the inept pharaoh who let all his slave labor go free. We walked through the Coptic church, ancient witnesses of the faith. In Egypt I committed to reading all of Martin Luther King Jr.'s works as well as Tom Skinner's, reminding myself that following Jesus is a global phenomenon and has been for millennia. It was a start.

I knew returning to church was the next step.

We joined a congregation and were active, and then came 2020.

As we quarantined, we witnessed George Floyd being mercilessly suffocated for almost ten minutes under the knee of a casually murderous police officer. We watched protestors tear-gassed in cities all around the country while the then-president held a Bible in front of a church—a signal to his base that he would continue to uphold his idea of Christian values. He was signaling to the same kind of Christians who wanted to debate me about Black lives mattering.

We couldn't just watch. I went with my friend Adam to protest alongside two thousand other people because I was grieved and angered by the murder of Rayshard Brooks. We were anguished that even a global pandemic couldn't slow police brutality. Yet the anguish and call for justice couldn't be hampered by the pandemic either. As we marched, we ended up de-escalating communication between the crowds and the police. We knew we were right where we were supposed to be. We were united in purpose and moved by justice.

I fled to Egypt and I protested because I didn't want to be gaslit anymore. I didn't want a spirituality that forced me to dissociate and numbed me to the foolishness of white supremacy. The church

is an organism. It's a group of people and a global movement. Church is the integration of lives where people are connected emotionally, spiritually, economically—where there's genuine connection. Jesus brought together tax collectors and the taxed, Jews and Greeks, doctors and fishermen. He united every kind of person under His name and endowed them all with the Holy Spirit. *That* was the blueprint for the church.

Each of us who follows Jesus is called to create a blessed community, to pull the kingdom of heaven closer to earth. We ought to be defined by the compassion and righteousness of who we follow.

We are the church. I believe the church is a living organism. We've started to treat our churches like branded corporations, and we've lost sight that the church is simply a group of people, transformed by Christ, doing life together. The Body is not a building, not a political platform, not a list of things we're against, not attendance rolls or star tithers.

It's us. The Body is us.

I fear that some of us have lost our first love. Churches that don't need Jesus are dangerous. The beauty and simplicity of the faith has been overlooked in favor of insider-outsider litmus tests and defensiveness. The good news is masked because there's a lack

of grace, burden-bearing, humility, and the convicting, counseling ministry of the Spirit. But there's good news. Jesus promised that the gates of hell won't prevail against His church. We gon be all right. We have the Holy Spirit, and the Spirit's power resurrects dead things. I am determined to be a part of the comeback story authored by the Spirit. I believe that we can stand up in this opportunity to reflect and refine how we function as the church, and expect God to work, just as He has before.

Would you join me? Let's be a body of disciples making disciples—not just followers in a stadium. Let's hold our local preachers accountable and encourage them to peel back the layers that are masking the good news.

Let's attend churches where our preachers know every congregant by name. Where women and men of integrity pray, teach, and serve. Where people work quietly, in faith, because they love across the lines. A real body of servant-hearted people is way more appealing to nonbelievers than a quippy sermon, political party, or neon light machine will ever be.

Let's show up for one another. Y'all are the blueprint.

THE BEAUTY AND SIMPLICITY OF THE FAITH HAS BEEN OVERLOOKED.

GAN
LAN

My cousin was a killer.
He done pulled a trigga.
He done made a lot of
 mamas cry.
If you ask him why he do it
he would say he young and
 foolish,
bang on you right before he
 let the bullets fly.

He ain't have no sense
 of dignity,
his daddy was a mystery.
He'll probably end up dead or
 sittin' in the penitentiary
and tell the judge that he
 can go to hell before his
 sentencing.
It probably make no sense to
 you but listen to the
 history.

The new Jim Crow or
 the old one
people out there fighting for
 the power of equality.
I think they owed some
back in Folsom.
Cleaver got a message
 for people
Bunchy wit him now they tryna
 stop the evil
and they cliqued up
 with they fist up,

got the whole neighborhood feeling like they meant something.
Then there was a mix-up, feds got 'em fixed up,
end of movement back to the bricks bruh.

Raymond Washington about to start the Crips up,
they getting bigger every day they tryna fix stuff.

They saw Geronimo Pratt dodging bullets from attacks.
I guess they figured we don't really want it this much.

They said CRIP stands for community revolutionary interparty service.
Way before the genocide and the murders
a little after integration was the verdict
when bombs might go off after Sunday service
they protecting they community.
Then it turned into diplomatic immunity
then the fight against oppression was depressin'
and they kept on losing battles so they started losing unity.

Now they beat each other blue black,
force-fed self-hate till they tooth crack.
Got they own folks hiding on the roof top.
They ain't finna take no more, they say they finna shoot back.
Bow.
Now they bond like family they all Bloods,
from the concrete jungle to the small hoods,
throwing signs up now the crime's up.
We was meant to kill oppression
now we load the 9s up.

But never mind us
Grindas.
Factory done closed, now a lot of people jobless,
now they got the drugs coming in from Nicaragua.
Government done turned a blind eye: "oh they godless."

Now the little homies riding round throwing sets up,
they don't understand the way the world is set up.
Find religion in the prison cuz nobody tried to get 'em fore they hit the street and now they life messed up.
Now they hate the white system and white Jesus.
They don't understand that He came from the East and neva been about His color but the blood that bleeds and died for the Vice Lords and the Gods.
We made for reason
and they believe it that's why they ride for the hood cuz they know they need 'em.
But when you die for the hood tell me what's the reason?
Because martyrs get killed for another's freedom.

So when King got shot and the world stop
he did more for the block than you know about.
And no this life ain't fair and the odds stacked up.

Imma fight my fears tho it's all jacked up.
We ain't never been afraid of the struggle and the pain,
we can make it out alive if we hold to the name.
Lineage is royalty, came from a king
made likeness
despite what they say

Lineage royalty child king
made in His likeness.

I idolized my uncle Chris growing up. He was ten years older than I was, but to me, he was the epitome of manhood. He was part of the Skyline Pirus—a gang. He went to prison, and when he came out, he was more glorious—permed hair flowing, more muscular, more confident than when he went in. Prison agreed with him somehow. My dad wasn't around, but Uncle Chris was. He'd scoop me up from the front porch where I played and let me ride around with him, blasting reggae or NWA. He would even let my big-head self take a turn at the wheel when I was around ten or eleven years old.

What struck me most about Uncle Chris, and is true to this day, was that he was the only man—the *only* man—in my life who asked me about myself. Then he would stop to listen to my answers. This young man, flush with cash and a nice car, with loyal friends, cared about what I thought, and taught me how to drive, how to load a 9-millimeter. He took time to mentor me.

MY INTRODUCTION TO GANG LIFE WAS A LOVING UNCLE.

A lot of folks get their education on gang life from the nightly news or an after-school special. You may know the colors affiliated with specific gangs or the brutality of drive-by shootings. Maybe you watched *Boyz n the Hood*. But my introduction to gang life was a loving uncle.

Gangs there are a bloody degradation of an original vision that had kinship, protection, and emancipation at the center. Los Angeles gangs, originally called clubs, were formed out of desperation and necessity.

After World War II, Black soldiers returned to America with none of the honor or financial help that their white counterparts received. Instead, racialized violence and lynching surged, especially in the South.[9] So some Black families moved west for a fresh start, often settling in previously white-only neighborhoods. Legal redlining policies and deed restrictions of Los Angeles forced Black people to squeeze into small sections of the city, stretching resources and creating subpar living standards. White gangs like the Ku Klux Klan and the Spook Hunters enforced the segregation lines by setting homes on fire and stabbing or beating Black children, women, and men who crossed them.

Black people did not trust police to protect and serve them, so they decided that protection needed to come from within. Black clubs, like the Devil Hunters, formed in order to retaliate. Later, the Black Panthers' armed response to injustice attracted many followers and started organizations like the CRIPs (Community Revolution in Progress)

and BLOODs (Brotherly Love Overrides Our Destruction) to protect their neighborhoods. But when several leaders were displaced or killed by CIA and FBI operations (COINTELPRO), followers were left with the swagger of afros and guns, but not the strategy or substance.

By the time I came around, gangs were still close-knit bands that protected their own and displayed a loyalty and pride for their communities, but they were ruled by violence. Violence touched our lives, inevitably. Philip, my uncle's friend and my aunt's boyfriend, was a part of our lives. One day I saw Philip smiling and high-fiving me, and then the next day everyone was crying and hanging obituary pictures up because he was murdered in a drive-by. Another time, my uncle busted through the door, bleeding everywhere. He had been stabbed by a rival, and I remember being so grateful that person had a knife and not a gun.

Gangs looked like freedom to me when my uncle Chris was thriving. But his example also made me wish I was also sent to jail, so I could be more of a man like him. How backwards is that, to look for freedom behind prison walls? How free were we when wearing the wrong color or walking up the wrong block could mean death for us?

Too many of us are running on hope's fumes. Proverbs 13:12 speaks of the sickness of heart that comes from hope deferred. Poet Langston Hughes remixed the proverb in a poem about deferred dreams drying up, festering and finally exploding.[10] Hopelessness can drag a people into desperation of all kinds. This isn't an apologetic for gang activity, but a plea to remember forgotten people. Gangs are a stopgap for people trapped in a paucity of options—a violent answer in a hostile world.

TOO MANY OF US ARE RUNNING ON HOPE'S FUMES.

This isn't new to God. He chose Moses—who stood over the Egyptian he killed to save an Israelite from being beaten. Moses was afforded an escape to Midian and decades to rehabilitate himself, yet his scars were deep enough to cause him to be reticent to lead the people of Israel. The people of Israel followed in their own broken way, in part because four-hundred-year-old trauma didn't get washed away in the Red Sea. Emancipation, a leader, and even manna from the sky didn't keep the people from murmuring and paranoia.

Please consider that long trauma and unbelief aren't quickly remedied with sermons about personal responsibility. Change takes contextualization and incarnation and so much time. If you don't know the context of a people or a place, it's okay to listen and learn without speaking. If you do speak, please consider that the Jesus you present needs to be the true One, as incarnational as my uncle Chris—not far off, not disgusted, not available only to people who live in immaculate suburbs. Jesus lived with humanity for thirty years before He began ministering, and came with compassionate action, the gift of presence, and a healing touch. Instead of wagging His finger with distant disdain, He was willing to lay down His life to free this world from the far-flung effects of sin and death.

CHANGE TAKES CONTEXTUALIZATION.

IF YOU DON'T KNOW
THE CONTEXT OF A
PEOPLE OR A PLACE,
IT'S OKAY TO
LISTEN AND LEARN
WITHOUT SPEAKING.

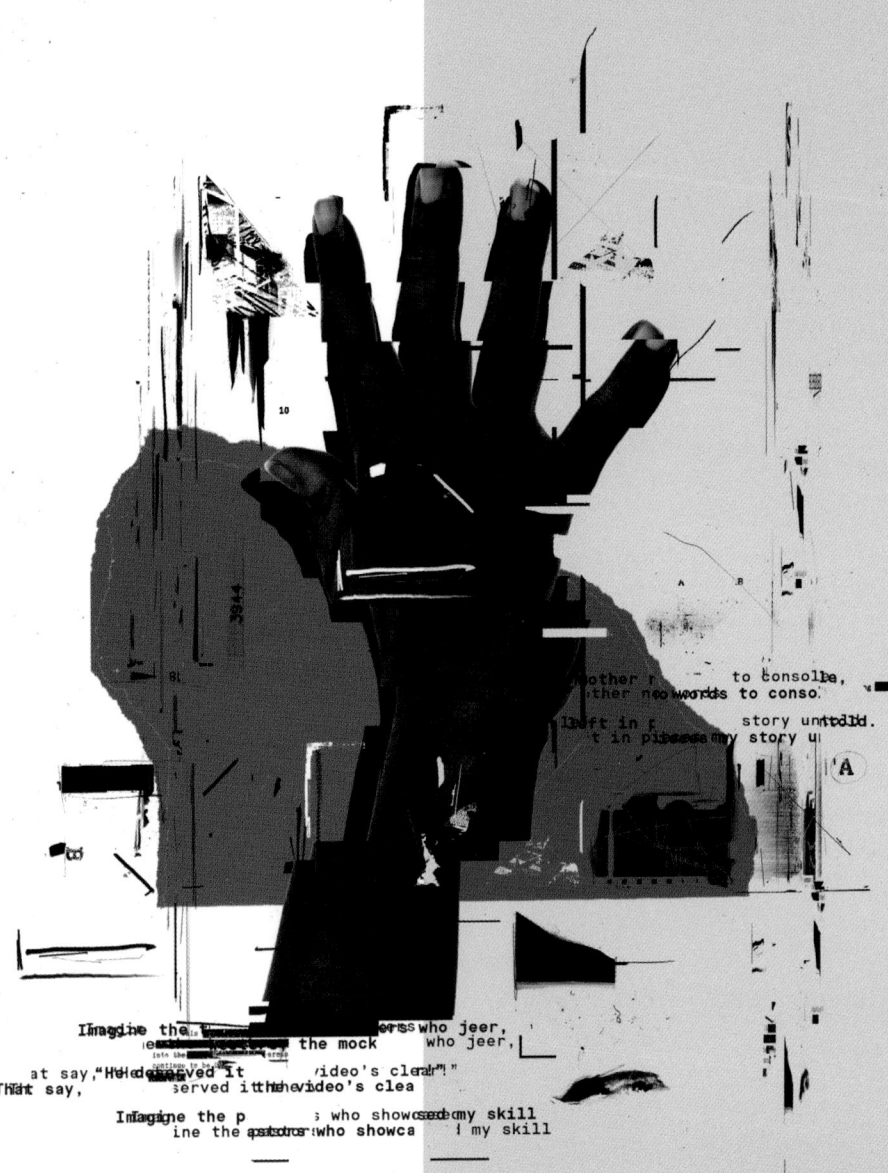

IMAGINE

 Caught between the two
 I fit the description of hashtags we've mentioned.
Sold drugs on my campus, abused my prescriptions,
 A vandal, a thief, the object of suspicion.
Now look at me living out this grandiose mission.
 Imagine they shot me the times that I stole.
Imagine controlling the fate of my soul.
 Imagine my mother no words to console,
 Her heart left in pieces my story untold.
 Imagine the tweeters, the mockers who jeer,
 That say, "He deserved it the video's clear!"
 Imagine the pastors who showcased my skill
All quiet about me the day I get killed.
 Now look at me living out this grandiose mission.
 Hope is my cure; joy is my ambition.
 Not the product of perception,
 not the object of deception.
 Imagine a soul with infinite worth
 known before my own conception.

I sat stunned as I scrolled through the reactionary comments on Instagram. The condemnation and hatred flowed so freely from people I presumed, based on their profiles and professions, were saved by grace alone. I had gone to Mike Brown's memorial and posted a photo taken while I paid respects. I included no caption. Some of the worst responses read like I had posted something subhuman. The comments were just damning. It disturbed me that those commenters couldn't see a shred of humanity in Mike Brown, a young man killed before he reached adulthood, whose body lay uncovered in the summer heat for hours.

THE DIFFERENCE BETWEEN ME AND MIKE BROWN IS THAT I WASN'T KILLED BEFORE I GOT THE CHANCE TO GROW.

I could have easily been Mike Brown. The difference between me and Mike Brown is that I wasn't killed before I got the chance to grow. That's the only difference. A life and death difference.

The cross section of commenters who let their children listen to my music and teach them the Bible yet called Mike Brown an animal boggles my mind. I could never have transformed into an artist or teacher or mentor if I were issued a death sentence for the many times I stole things from convenience stores.

I was even featured in a Billy Graham series that recalled the time I pulled out a gun and pointed at a woman's car for fun with my friends—my past was used as an example of how God's grace transformed my life. Respectability, the cut of my clothes, or my articulation didn't save me: Jesus did. Jesus and time and people who imagined a better me than I did for myself. But if the police would have shot me in the street that day, there would be no testimony. You can't transform if you're dead.

People held me up as a poster child for reformed theology, and, I think, a reformed life. I basked in that special status—until I was castigated for talking about Black death. I used to think that knowing the hermeneutics of white pastors and being able to reiterate and explain theological concepts made me respectable. I thought of myself as a bridge between reformed theology and Black theological ignorance. How arrogant I was! I had to let that go. I'm grateful

YOU CAN'T

TRANSFORM IF

YOU'RE DEAD.

for the hateful responses to my attention to police brutality and racism—they were revelatory.

The hate made me realize that I had to embrace the whole of my journey, because I'm not just the worst parts of my story. I'm also not just the summation of all the respectable behavior. I'm all of it. We all are. That's the beauty and the complexity of humanity. Respectability wouldn't save me. I needed to understand that no matter how much I could quote conservative, theological, biblical frameworks in my music, I'd never be a part of the upper caste. Racism can never respect me. Playing violins for cats and being a gentle soul didn't save Elijah McClain. Wearing suits, having a PhD and being a reverend, and protesting nonviolently didn't preserve Martin Luther King Jr.'s life. Unfortunately, we live in a society that deems some people guilty without a fair trial, without any chance at rehabilitation, second chances, or growth. God grants fresh mercy every morning, but too many times, law enforcement and the court of public opinion don't—not when it comes to Black and brown bodies. This racist system has a god complex that robs the world of futures that have the potential to love well, care for their families, and flourish.

Part of getting free—and creating an environment

> **THAT'S THE BEAUTY AND THE COMPLEXITY OF HUMANITY.**

where others can experience freedom—is having the space to grow beyond our worst moments. To be clear, this doesn't mean that people should be "free" to abuse or kill anyone (whether they hold a badge or not). What I mean is that growth is corrective *and* restorative. This takes more nuance and attention to the details of a person's story than one can glean from a sound bite or a Facebook post. I am so thankful for the people in my life who imagined a better me and saw the hurt, fatherless boy who searched for any kind of anesthesia to ease the ache of insignificance. They acknowledged my mess and called it what it was, but they also imagined a future filled with healing and encouraged me to do the work to get there.

Imagine that you could be instantaneously judged guilty and sentenced to death based on your worst moment—a lie, a felony, a thought, an opinion, an action. Would you still be here?

What if our imaginations were fueled by a grander vision than accusation, condemnation, exploitation, and murder? We could be bringers of conviction and restoration. Micah 6:8 calls us to act justly, love mercy, and to walk humbly with our God.[11] What if that could be the fuel for our holy imagination, individually and collectively? People of Jesus are people who love life and want it in abundance, *for everyone*. It

takes no imagination to be one of the crowd, screaming for crucifixion. This is opposite of "imagining"; it is "accusing." That's a tool of the Enemy, not the people of light. The people of light have grand imaginations, rooted in mercy, rooted in hope.

> **THE PEOPLE OF LIGHT HAVE GRAND IMAGINATIONS, ROOTED IN MERCY, ROOTED IN HOPE.**

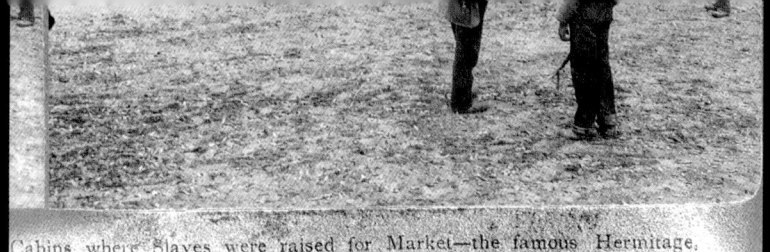

Cabins where Slaves were raised for Market—the famous Hermitage, Savannah, Georgia. Copyright 1903 by Underwood & Underwood.

Cabins where Slaves were raised for Market—the famous Hermitage, Savannah, Georgia. Copyright 1903 by Underwood & Underwood.

MARTYRS

I been pushing hard I been praying harder.
The dark corners of the earth took my earthly father.

Martyr me,
promise me to death.
Walk me into my grave. I'd rather die a free man
than live on earth a slave.

I'm fighting for people they put in chains,
stripped our heritage and took our names,
put our women to shame,
whipped us and beat us,
Misled us,
but they ain't kill our passion.
Take my body but my soul won't fit inside yo casket.

Taken from Africa, treated like animals, culturally
 denigrated, and broke up our families,
prison of false religions.

The same God you lied on…
The same one that I survive on
Imma strive on.

Alone, just a small tribe
fought for truth and we all died,
but martyrs live for forever so out the depths we will all rise.

Died for a freedom that we'll never see,
I pray y'all live it to fullest for the legacy.

Nappy heads and perms
we went to college to learn.

Morehouse to Spelman from Howard to Hampton
got reeducated with the right appreciation for Fred Hampton.
Our grade school a scam.
Relearned my church history, most of it never mention me.
Brown, black, yellow and red was all missing, G.

God opened mine and had me think,
Was the great awaking great if minorities didn't wake up?

I stay woke with sound mind
I'm floating on cloud nine.

I hope you find vision…. I found mine.

μάρτυς (martys). n. masc. **witness, martyr.**
A person who witnesses and, perhaps, has been killed as a result.[12]

I am a poet, and I stand on the shoulders of generations of poets, some praised and some obscured. Phyllis Wheatley. Paul Laurence Dunbar. Langston Hughes. Claude McKay. Gwendolyn Bennett. I am alive by God's grace and the survival of so many people whose names I won't know on this side of glory.

We are witnesses.

Our lives are a witness to many things. First, the goodness of God, because if it were not for the Lord, who preserved our enslaved ancestors within a carnivorous system that sought to breed, consume, and abuse us, we would not be here today. Our DNA is a love letter of survival. Second, we are witnesses to the power of the gospel of Jesus Christ, because the Spirit was at work in us when we were barred by law from reading, had parts of the Bible purposely kept from us, or had to steal away to hear its words. Frederick Douglass bore witness to this when he described the secret effort to teach enslaved folks to read during Sabbath School.[13] Douglass's school was later broken

> **OUR DNA IS A LOVE LETTER OF SURVIVAL.**

up by white church leaders wielding sticks and stones. We kept the biblical stories of enslavement, liberation, unjust killing and sacrifice, and the hope of resurrection, alive within our bodies, in our hearts and minds, as we stole away to worship, in ring shouts[14] and baptisms. And lastly, we're a witness to the hypocrisy of a "Christian" nation that boasts "liberty and justice for all," while willfully failing to deliver what it claims.

This witness was, and continues to be, costly.

Look, I know some readers are going to read this work and be offended by the way I center Black experiences and people (in which case this book will be a real challenge to read). I admit that there was a time I would have gone out of my way to make the offended folks feel more comfortable. Part of getting free for me has been recognizing what's worth apologizing for. I am not apologizing for the skin I am in. I am not apologizing for stating how things were for my Black ancestors who experienced no great emancipation following two Great Awakenings. I am just the latest in a line of witnesses to the history that says to be Black in this nation means to be surveilled, violated, and often murdered.

Just acknowledging my own Blackness and grief in connection with extrajudicial killing has cost me followers and opportunities. I don't regret it; these

I AM NOT APOLOGIZING FOR THE SKIN I AM IN.

losses are nothing compared to the indignities that my ancestors suffered. It's nothing compared to what happened to Breonna, Ahmaud, George, Tamir, Sandra, Botham, Trayvon . . .

I used to feel some kind of way about being a Black Christian. Like, *Is my Blackness somehow a burden to my witness? How does my Blackness interact with my faith in Jesus?* I unintentionally bought into a version of living out the faith that dipped everyone in spiritual bleach. To be *really* sold out for Jesus was to deny ontological aspects of myself—the place, time, and culture in which God placed me—and instead pursue a colorless, tasteless faith.

In your walk with God, you may encounter the Galatian Problem: people who tell you that to follow Jesus, you have to forsake your culture and act like *them*. They want to put a barrier between you and Jesus—and they may mean well. In the book of Galatians, the Jewish believers wanted Gentiles to be circumcised first, and then follow the Way of Jesus. They desired to colonize their new members rather than celebrate the expansion of the believing community. Paul rebuked them for it! Their bias placed their tradition and culture above the work of the Spirit in the lives of people of other cultures—and made for a hypocritical witness.

> **IS MY BLACKNESS SOMEHOW A BURDEN TO MY WITNESS?**

Nah. That version of faith flattens and reduces the cultural and ethnic creativity of God, the intentionality of God, the flawlessness of God. The *nations* glorify him, and according to Revelation 7:9, we'll be hearing and seeing distinct tongues and tribes breaking out in worship to God. To lean fully into the swagger, creativity, lyricism, and beauty of my heritage as I follow after Jesus makes me a more authentic witness. Free to worship in my skin. We do not have to spiritually bleach our skin and culture to be received as children of God.

Let my life and my work be a witness to this. And may yours too.

> WE DO NOT HAVE TO SPIRITUALLY BLEACH OUR SKIN AND CULTURE TO BE RECEIVED AS CHILDREN OF GOD.

PART 3

RESISTANCE

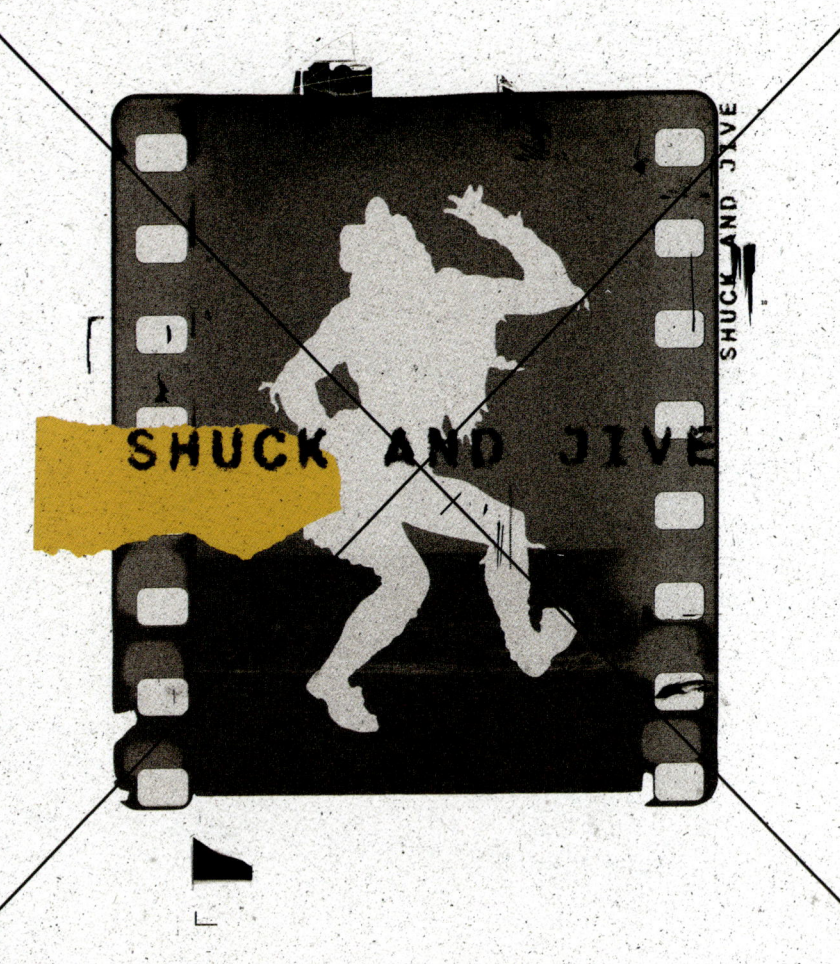

Feet, joints, and soul
 sore from years of
 performing the same
 choreography with a grin.

My worth is nothing more
 than my movement.

Hairs gray and bonnets faded
 from concocting sauces,
 syrups, and rice recipes
 to be in your kitchen
 but not at your table.

Overwhelmed by the demand,
 as my work creates a
 legacy, I mean dollars,
 I mean monopoly for
you but an empty
 legacy for me.

I lift you to the heavens
 with my voice.

Notes that you eventually
 appropriate without credit.

I mean who am I if I'm
 not entertaining you?

But who are you without
 someone to steal, I
 mean borrow, I mean
 be inspired by
As I run, jump, and score
 billions for you?
Am I a waste of talent
 (scratch that) life
 if I walk, sit, and write?

You love my moves, my food,
 my soulful grooves
 my zips, my zooms, my
 cool trap swoon.

But what of my wounds

What of my doubts

What of my chains

What of my grief

What if I'm more than the
 things you consume

What if I'm human

Would it matter to you?

No Black person wants to be accused of shucking and jiving—you might as well call us a show pony, puppet, or even an "evangelical mascot."[15] The term "shuck and jive" is a specific critique of Black folks who perform for the white gaze; it's putting on a performance of conformity or obedience to please the majority white culture.

It's not a flattering picture.

I remember when I first got wise to the dance I was doing: it was when I tweeted about Trayvon Martin's murder in 2012, and received a tsunami of backlash for it.

```
"Disappointed in you, Lecrae."
"Thought you loved the Lord."
"He was clearly a criminal."
"I followed you for years and this is
    very disappointing."
```

Prior to this tweet, I was the evangelical golden child, beloved and welcomed by the evangelical elite. I was basically commissioned to be a missionary to The Blacks™, sent to speak in their language and enlighten them (pun intended). So when I received vitriol in response to my tweet, I thought I just hadn't

phrased it well enough. I thought I would put out a clarifying video to explain myself and remain in their good graces. I thought I would explain that Trayvon reminded me of the kids I cared for in Memphis and Chicago; that I wore a hoodie all the time; that Trayvon could have been me. I didn't see the invisible bonds of people-pleasing and acquiescing to white supremacy, pulling my strings.

The backlash was even worse after I posted the video. It was revelatory. I was aghast and kept repeating to myself as I scrolled, "This is how people think? This is how people think." I should have cut the strings that bound me then, but I kept dancing.

> **I SHOULD HAVE CUT THE STRINGS THAT BOUND ME THEN, BUT I KEPT DANCING.**

I thought if I kept performing at their conferences and talking about Jesus and the supremacy of the gospel, I'd be accepted.

Shucking and jiving did me almost no favors, save

one. It showed me what I worshiped instead of God: conflict avoidance, the white gaze, approval.

God's ways are rest and follow, not shuck and jive. The way of God prioritizes the person, not the performance. The way of God prioritizes rest, not greed. The way of God counteracts the exploitation of Black bodies and souls and invites us into reflection and thanksgiving. Imagine who we would be if we could express our creativity out from under the oppressive yoke of the almighty dollar?

THE WAY OF GOD PRIORITIZES THE PERSON, NOT THE PERFORMANCE.

Maybe you've experienced a similar tension between God's way and the world's way. Maybe you've spoken out about injustice, but it made your employers uncomfortable, so they asked for your silence. Maybe you're worshiping at a church that professes to care for the afflicted but asks you to stay silent about topics of race. If so, you're not alone.

What's at stake if you live differently? If you're compromising because your livelihood and family

depend on it, you get no judgment from me. I empathize with you. It was hard for me to get free from the shuck and jive when the livelihood of my family and others depended on my performance. But I became a slave to the thing I hated doing as it slowly took away my humanity. I believed the shuck and jive was all that God had for me. I stayed doing the only thing that I thought I was good for, and it broke me. Thankfully, there's life after the breaking.

Where are the places and people that make you feel most like yourself? What would it take to spend more of your day in these kinds of places? Do you need to move? Change your job? Change your church?

I don't know what it will take for you to be freed from the daily pressure to shuck and jive, but I do know that God is not asking you to surrender your dignity. It might be hard to change, but there is freedom on the other side, and God will walk with you through it.

> **GOD IS NOT ASKING YOU TO SURRENDER YOUR DIGNITY.**

MOTIVES _ I STARTED OUT DREAM, FILLED UP A RHYME THE SEAMS. / THE LABELS IT OUT ON THE STREETS, PROJECT TO ANYBODY I THE MONEY OR FAME OR FUNNY WHEN IT COMES THEY HAVE CHANGED. / COULD AND CHAIN WITH DIAMONDS INSTEAD, WE HOPPED ON SPREAD HIS FAME, AND CRITICS JUST SLANDER

WITH A PEN AND A CHILDISH BOOK TILL IT BUSTED OUT OF NEVER HEARD IT SO I TOOK AND I'M PASSING OUT MY MEET. / NEVER DID IT FOR PERSONAL GAIN, BUT IT'S ASSUME YOUR MOTIVES HAVE BOUGHT SOME PIECE TO SPELL MY NAME. / BUT PLANES TO TRAVEL AND IT HURTS WHEN ALL THE YOU TILL YOU'RE SLAIN.

I have always been at home in hip-hop because it's the flavor of my family. My mama raised me on *Soul on Ice* and *The Autobiography of Malcolm X*; the lyrical swagger and intellectual prowess flowed from Black Panthers and Black scholars with such ease. My uncle Chris would pump Buju Banton, Gregory Isaacs, or Dr. Dre as we rode down the boulevard with the speakers clinging to life as they were challenged by the bass and 808. Hip-hop is such a potent form of Black American eloquence, and I am fluent.

After I met Jesus, hip-hop became the vehicle of evangelism, theology, and worship to me. Hip-hop is where my fervor, my doubt, my confession find bars. My rhymes have grown with me as I have expanded and experimented and matured. I was discipled into the Cross Movement era, when reformed theology was coming out in rhymes and cadences from guys who looked just like me. I wanted to reach young people the same way they reached me. My motives were pure.

When attention came my way, I was just as shocked as everyone else, maybe more so. All this to say, my motives have had little to do with securing the bag. Now, I would be lying to you if I said that fame and wealth didn't become tempting once I actually

> **HIP-HOP IS SUCH A POTENT FORM OF BLACK AMERICAN ELOQUENCE, AND I AM FLUENT.**

had access to them. For anyone struggling to feel seen, receiving affirmation on a large scale can be intoxicating. I can honestly say, though, my motives for creating are not about money or fame—I was rhyming for my life way before I got paid for it. Nah, I do it because it's like a fire shut up in my bones. It has been a door to freedom that God gave this confused kid through the gift of rhyme and meter. The music is a process, and the music helps me to process.

Somewhere along the lines, though, my motives began to shift. The approval of evangelical leaders meant more to me than my wholeness. I was shackled to a predominantly white evangelical fan base's opinion rather than my own artistic expression. I compromised so much of myself. I willingly held some portions of my Blackness back in my production choices so that I could appeal to white evangelical audiences. I saw myself as a missionary to the streets rather than a native son and kept my Blackness on the side. And my white mentors loved the hip-hop, but not necessarily the culture that birthed it.

I felt myself separating at my soul's seams.

I played my songs for the kids I mentored in Memphis and they said, "Yo, this is *wack*!" They played me the songs that they listened to, and it was like remembering myself and the musical atmosphere

of my youth. I had forgotten that I set out to make music for *these* kids, the young people fluent in hip-hop. My friend Tyree Boyd-Pates, a historian and museum curator, made it plain when he lovingly rebuked, "Your music lacked the phenotype of Black people."

Returning to my original love of music helped me to reimagine my sound, lose the acoustic guitar solos, make the beats grimier. As my music relaxed into my origins, so did I. I grew out my hair and started growing locks. As I turned my music back toward the community that birthed me, I was criticized by some of my white fans. One word came up repeatedly: *worldly*. My music was worldly. My hair was worldly. I can't confirm this, but the way the word was used against me makes me believe *worldly* was a stand-in word for "too Black." My choice to integrate myself—be Black and Christian in my art—caused a lot of white evangelicals to stop supporting me. At the same time, though, I gained new supporters: the people who could speak the language of my music.

On my worst day, my motives were foul because I just wanted to be accepted by evangelical elites, or because I wanted to be the biggest star in the world. And yet, when I was content to be in bondage to the white gaze, God wanted me to be free. My dual

reality living doesn't glorify the God who made me and placed me in a specific context. My desire to please people is an idol keeping me from following Jesus, and I'm determined to keep fighting against that desire.

What are your motives? What are their origins? Are your motives connected to the approval or consent of other people? Can you identify your motives, or have you lost your way?

We have a rabbi to follow when we stray, who leads us down the right path. I'm now free to make the music that I feel like God is calling me to make. I know who needs this music; it's for people who are receptive to the language I'm speaking in the beats, the music, the lyrics.

There will always be people misinterpreting or judging your motives—you can't please everybody. Freedom is relaxing into the ways God made you and flowing in it. Like a diamond, you have many facets; God's light makes you glow—unless you hide. But the One who knows your motives best can also guide you when you're lost.

> **FREEDOM IS RELAXING INTO THE WAYS GOD MADE YOU AND FLOWING IN IT.**

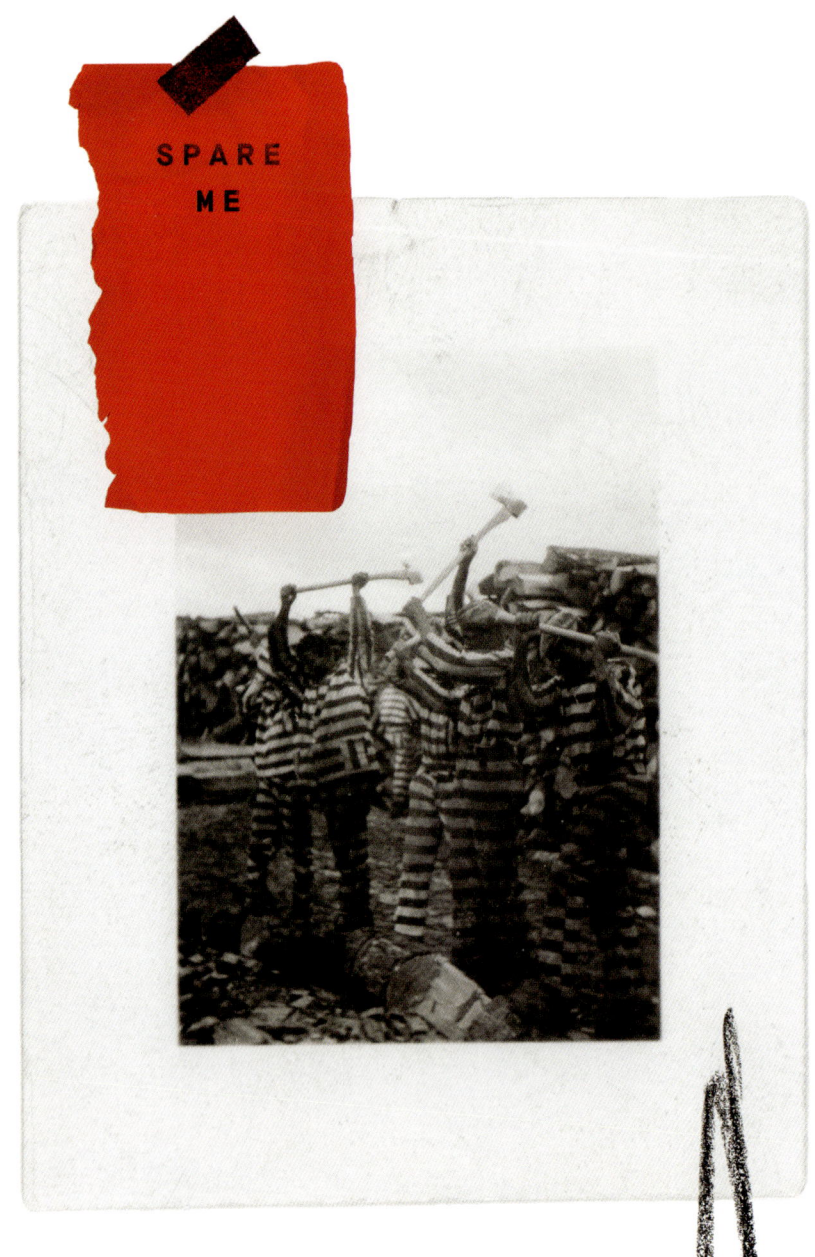

Joblessness contributes to violence and crime.

 My school doesn't teach what I need to survive.

Black men are disposable, demonized as lazy.

 No cotton to pick, no need make babie$.

 Scapegoats locked up and locked out of society.

No jobs and future…no need for sobriety.

 The patterns of drug laws and prison are scary.

 But…

 "What about"

"What about"

 "What about"

 Spare me.

Soul food was the stubborn creation of a people bent on tasting home as we fought off starvation. We gathered the offal, the cast-off meats, and made feasts from hog's head, tripe; from feet and bones; from vinegar and salt. It's magnificent, really, how enslaved people, robbed of motherland and mother tongue, found themselves in the churning and turning, seasoning and pickling.

But I won't pretend we weren't given the worst and expected to survive and perform as well as anybody else. I won't ignore the steady callousness of white supremacy that demanded the relentless preparation of sumptuous meals by our skilled hands, and then refused to let us have even a portion to fill our bellies with what we cultivated and cooked. People offer ahistorical, color-blind arguments every day as majority culture dissects the failures of Black people without acknowledging centuries of neglect. One particular instance of weaponized ignorance always elicits a deep Negro sigh from me:

"What about Black-on-Black crime?"

Yes, Black people commit crimes against one another. Yes, crime is bad. But here are some of the

trends I have noticed surrounding the lobbing of this question into discussion:

- **The speaker is devoid of compassion.** There's no follow-up of "and what can *we* do about it," because the speaker is usually not invested in problem-solving; rather the speaker exploits the existence of intraracial crime to make a larger point, usually inferring that Black people are inherently more criminal, or that liberal cities allow crime to run amok.
- **The speaker is unaware of intraracial crime trends.** Crime happens in proximity, in all neighborhoods. So white people commit crimes against white people, just as Black or Latinx or Asian people tend to commit crimes against their neighbors. (Poverty level, not race, tends to be a significant indicator of crime potential, according to the US Department of Justice.[17]) Ironically, the speaker doesn't realize there's an indictment hidden in the question of "Black-on-Black" crime: American neighborhoods are structurally segregated. Black people aren't the architects of city planning, zoning laws, real estate bias, or redlining in this

country. Real estate segregation is the creation of white people in power. The folks who ask about Black-on-Black crime are making it clear that they do not live next door.

- **The speaker doesn't know what's already happening.** The neighborhoods that people like to casually complain about most likely have community leaders promoting nonviolence, advocating for commonsense gun laws, ministering to people in prison, cooking and raising funeral funds for the bereaved.

Earlier in my career, I moved to North Memphis, one of the toughest communities in the city. I had the opportunity to mentor several boys. Of the kids I mentored, Dennis, got arrested and spent years in prison. Jay was murdered. Chris got caught up in the web of addiction. Dan-Dan went to the military, completed his service, and got involved in mortuary services. He knows the Lord, and he runs a mortuary company in Memphis. (And yes, there is a bittersweetness in observing his thriving business predicated on consistent death.)

To the people who ask, "What about Black-on-Black crime?": you don't know what it's like to be trapped in the American nightmare. And my question

is, in what year did America change from separating, exploiting, vilifying, and abusing to recognizing, supporting, and protecting Black families? The trap is real and oppressive. The whatabouts are a cold response to a persistent problem, strategically ignoring the humanity of people not deemed as neighbors.

YOU DON'T KNOW WHAT IT'S LIKE TO BE TRAPPED IN THE AMERICAN NIGHTMARE.

The Way of Yahweh is different: it presses down mountains and raises up valleys to create equity and justice where none existed. As believers, we can be casually callous, or we can exercise compassion and depth as we observe the conditions of other people. Whataboutism echoes the cold repression of Pharaoh in the book of Exodus.[18] When Moses called attention to the plight of the Israelites, Pharaoh called them "lazy" and increased their labor. He inferred the superior work ethic of the Egyptians and explicitly punished the Israelites for asking for better circumstances from those in power.

> **"WHATABOUTS" ARE BLINDFOLDS KEEPING PEOPLE APATHETIC.**

"Whatabouts" are blindfolds keeping people apathetic, because if they can justify the disparities in their mind, they don't feel challenged to have to have a new worldview or to contribute to change. They don't think they're personally responsible for any neighbor's poverty, so why should they be responsible for the solution?

The Bible gives us a model for how we must collectively care for one another as both the advantaged and disadvantaged: we prepare a big table. In Exodus, God ensured that the Egyptians loaded the Israelites with gold and silver before they sojourned to freedom. In Leviticus, the Lord commanded the Israelites to reserve a portion of their crops to provide for the poor and the foreigner. In Acts, believers held all things in common so none had need. God doesn't despise the poor for their situation. Instead, God instructs the privileged to corporately provide for their neighbors, as God provided for them. All throughout the Old Testament, God reminded the Israelites, "Remember that you were once slaves in Egypt, and let that memory form your present actions toward the people who are most vulnerable."[19] God gives His people, then and now, provision so that they can bless others. At our big table of love, no one should go hungry.

AT OUR BIG TABLE

OF LOVE, NO ONE

SHOULD GO HUNGRY.

TAKE A KNEE, PEOPLE RIOT.

TAKE A BULLET, PEOPLE QUIET.

I remember the profound silence of my white Christian siblings when Tamir Rice was murdered by police—an innocent twelve-year-old boy, playing with a toy at a park. I remember the loud outrage of the previously silent—zealous to defend the American flag from Colin Kaepernick, who silently took a knee during the National Anthem.

Which symbol, Tamir Rice's body or the American flag, is fashioned in the image of God?

How backwards our allegiance and our worship can be. How broken.

Former NFL player Colin Kaepernick followed his conscience when he took a knee, in an act of nonviolent civil disobedience. His protest was carefully considered, even consulting with a veteran in order to devise the most respectful way to both honor fallen men and women and protest against racial inequality.

He did not riot, he did not burn anything down, he did not raise his voice or rally people to storm the Capitol, yet the response Colin Kaepernick received was relentless, swift, and violent. (You can't tell me that a US president referring to Kaep as a "son of a bitch"[20] isn't violence.)

Kneeling was a completely peaceful act, but people took offense, calling Mr. Kaepernick's actions disrespectful to the flag. So many of us watched the

uproar around the flag, laughing bitterly because this piece of property—an abstract symbol—was given more care and respect than a man protesting to protect the flesh-and-blood Black body.

KNEELING WAS A COMPLETELY PEACEFUL ACT.

Around the time of Kaepernick's silent protest, at my kids' school, some of the students wanted to start taking a knee during games. Some of the parents were in an uproar. The head of the school formed a committee to discuss the situation and invited me to join. I talked to parents who had *never* considered the root of their outrage, and how they came across as borderline worshippers of the flag and the nation. I was the first person to ask them, "Have you considered that people want to be heard? That they're not saying, 'We hate this country,' but 'We demand this country uphold her promises'? Would you be mad at your children if they said, 'You said you were gonna take me here and you didn't, and I'm upset at this'?" I am not sharing this discussion to pat myself on the back, but to bring attention to the reality that there

are so many people who are satisfied with an unexamined patriotism that silences and punishes their fellow Americans. There's a nationalist-type of arrogance (and it has infested many churches) that loudly lauds flag protection over the lives of Black people.

Allow me to address this question since I've had the same falsehood wielded against me that was used on Colin Kaepernick: "You're successful, famous, wealthy—how dare you protest when you're successful?" Wealth and fame do not inoculate Black people from racism. Wealth is an added tool that I as a follower of Jesus can utilize to bring His kingdom closer, not an excuse to opt out of the plight of oppressed people. I certainly hope that people of means are not tuning out the hurting of economically disadvantaged people.

The outrage over Colin Kaepernick's democratic protest is the exact opposite of patriotism, and more so, it's unchristian to never examine *why* the protests are taking place. We don't look at the Exodus narrative and condemn the midwives who refused to commit the perfectly legal execution of Hebrew boys. They boldly responded to Egyptian decrees by saying, "Hebrew lives matter." They chose life in the face of Pharoah's death-dealing decrees, and we celebrate them for that—as we should.

WEALTH AND FAME DO NOT INOCULATE BLACK PEOPLE FROM RACISM.

Black lives matter to God, and they should matter to us too.

Taking a knee cost Colin Kaepernick his career. To this day, the National Football League hasn't issued an apology to Mr. Kaepernick, even as the world bent a knee along with him. The NFL eventually released a general apology for not listening to its players speaking out against oppression, but Mr. Kaepernick? Well, he's still out of a job.[21]

My prayer is that the people of God will be loud about the right things. The image of God is not in the American flag; it's in people—all of us. We should not be afraid to shout, or kneel, to say, "Let our people go!" We should hold one another most sacred. We must see people as human and tear down American idols of nationalism and comfort. We must apologize to those we've wronged and make remedy for it.

The people of God must understand that if we're following Jesus, we are more likely to be in the position of courageous protest, isolation, rejection, and blackballing than political power and popularity. Being free in Christ means having a peace that passes understanding because we are walking according to the love of God. Jesus was crucified for His righteousness, because He angered and threatened religious and political power, because He taught women,

> **BLACK LIVES MATTER TO GOD, AND THEY SHOULD MATTER TO US TOO.**

touched lepers, dignified Syrians and Samaritans, and informed anyone who would listen that thus is the kingdom of God.

Nationalism is not a tenet of following Jesus. Sacrifice is. Justice is. Grieving with those who grieve is. And we ought to applaud that wherever we see it. As you consider how to engage justice in your sphere, I pray that you would be bold, kind, clear, and Spirit-led. I pray that you will learn to do good, seek justice, and correct oppression,[22] as the prophets commanded.

> **NATIONALISM IS NOT A TENET OF FOLLOWING JESUS.**

WE MUST SEE

PEOPLE AS HUMAN

AND TEAR DOWN

AMERICAN IDOLS

OF NATIONALISM

AND COMFORT.

REMIND MYSELF

All throughout the Psalms it is written:
 He delivers.
 He answers.
 He saves.
God is a deliverer, that's what He does.

We think our situations are a lil different
 as if our new ways of living
 make Him indifferent,
that the God of the Old Testament
 is spent in preeminent
 grace no longer covering
the sins I keep discovering.

I have to remind myself:
 My God pardons prisoners
Heals diseases
 Restores broken relationships
 Reverses the diagnosis
 Brings wayward children home
 Sends money to pay overdue bills
 Fixes marriages
 Cures anxiety and depression
 Same God.

I try to put myself in the shoes of the Israelites after four hundred years of Egyptian enslavement: After centuries of God's silence, what did they remember of Him? Did they remember the God who moved Abraham from his hometown into the unknown to establish a covenant for his offspring? The God who placed Isaac—the boy they called Laughter[23]—in his cynical ninety-year-old mother's womb? The God of Jacob, the trickster,[24] who stubbornly wrestled with arrogance, and yet was the namesake of the people of Israel? Did they remember God's provision for His people as they toiled? Did they believe that this God was still real, still the same God?

When God revealed Himself to His people, He called Himself "I Am." There's no past or future tense with Yahweh. God is constant, through and through. Simply and always.

But we still operate under the same cynicism and disbelief of I Am. On this side of hundreds of years of chattel slavery, generations who suffered experienced no Red Sea moment where, laden with the valuables their enslavers gladly gave under Yahweh's persuasion,[25] they set out for their promised land. Indigenous peoples still languish, miserably separated from their ancestral lands. The stories of oppression

ring out worldwide, without a man with a staff or manna floating from the clouds.

Can the same God who made a people out of a childless couple, broke the yoke of slavery, and made a covenant with His people be the God of *this* era? Can the same Father, through the power of the Spirit and who raised the Son from the dead, still reign as a wonder-worker? Is God still with us?

IS GOD STILL WITH US?

I don't blame you if you roll your eyes and mutter no. I have been there. I have felt numbness and despondency so many times. I've felt so spiritually lost that I considered leaving Christianity altogether. I am praying for those of you who are reading these words, feeling numb, clenching your disappointment and doubt, that God will meet you where you are. I pray that *God With Us* would be known to you, not because you earned it, but because God sees and cares. And in the meantime, I pray that God would place loving, supportive people around you who don't hurl Bible verses like weapons, but rather sit with you in your doubt.

I want to encourage you—and some days you will need to encourage yourself—that the wonder-working God who filled the pages of Scripture is the same God at work today. I reflect on these scriptures to steady me in God's presence when I feel doubt:

> "I the Lord do not change. So you, the descendants of Jacob, are not destroyed" (Malachi 3:6).
>
> "Jesus Christ is the same yesterday and today and forever" (Hebrews 13:8).
>
> "Every good and perfect gift is from above, coming down from the Father of the heavenly lights, who does not change like shifting shadows" (James 1:17).

I have to testify about God's constancy and faithfulness, because I have known it myself. The same God who made a way for Joseph to reconcile with his brothers brought reconciliation to my home after I was distant, thoughtless, and unkind to my family. The same God who humbled Nebuchadnezzar and brought him to his senses got a hold of me when I was chasing the affirmation of my peers. The God of the Bible showed Himself a miracle worker in my own life, and I am so grateful.

THE SAME GOD IS AT WORK IN YOUR LIFE.

The same God is at work in your life. We have a faith tradition that coincides with hardship, suffering, and disappointment. This is actually good news. Some shallow theology would have us believe that the presence of troubles means the absence of faith or the absence of God. The truth is that God is with us in all of it, working in the hush of pain and providing a way out that blesses us and brings Him glory. I am thankful for the testimony of people who had faith during what I call "the three-hundredth year"—symbolic of the time when the Israelites were entrenched in enslavement to Egypt and there wasn't a hint of Moses or liberation. The faithfulness of the saints who believed during the silence is a tutor for us on endurance. They believed a better day would come, and so many saints lived toward that end, through their generosity, love for their neighbor, fight for justice, and care for their loved ones.

I believe the same God who cut through the silence, remembered His people, and acted on their behalf will remember you too. This same God continues to confound doctors, divorce lawyers, and landlords. God is still bringing children home and mending broken families. The Lord is still close to the brokenhearted and crushed in spirit. Encourage yourself: God is.

PART

PERSISTENCE

I WROTE A SONG TO CHANGE THE WORLD
WITH THE HANDS THAT YOU CRAFTED.

I SANG IT IN FRONT OF MILLIONS
WITH THE VOICE THAT YOU PUT INSIDE ME.

I TOLD STORIES OF THE WONDERFUL PLACES I'VE BEEN.

THE ONES THAT YOU SHOWED ME.

THEY ALL CELEBRATED MY GIFTS.
THE ONES THAT YOU GAVE ME.

THEY LOOK AT ME LIKE THE MOON.
THEY WONDER AT MY LIGHT.
THE TRUTH IS
IT'S THE SUN THAT MAKES THE MOON
SHINE SO BRIGHT.

I know where my help comes from—the Lord, the maker of heaven and earth. I could no more take credit for my life, health, and career than I can take credit for the sun shining. When I think about the goodness of the Lord, how He has been a father to me when I had none, a mother to me when the pain of living was too much to bear; how He gave me this voice and my mind; how He gave me the poetry of those who came before—when I think about the generous love of this all-knowing God who still chooses to be with me, I am overwhelmed with gratitude and praise. Emmanuel—God With Us—is holy and wholly real.

(I might need a praise break!)

I stand tall because I stand on shoulders of poetic giants who came before me. I get to spit rhymes to packed rooms on tour because of the generosity of my followers who support me. I can pursue these dreams because my family grounds me. For every achievement, every album, every stage, there's a story of people who advocated, recommended, and opened doors.

I honor Charles and Emeline Bryant. Ancestors, stolen from West Africa and enslaved to labor. Freed and laboring for themselves—enough to birth twelve children and own eighty acres within mere years of

I STAND TALL

BECAUSE I STAND

ON SHOULDERS OF

POETIC GIANTS WHO

CAME BEFORE ME.

the Emancipation Proclamation. Lived long enough to prosper and then have their land stolen for a song. But they kept going. I honor their tenacity. I stand on their shoulders. And their strength, wisdom, and care come straight from God.

Never forget where you come from, and always remember how far God has brought you. I take this lesson not just from my life but from the pages of Scripture. After Yahweh brought the children of Israel out of the bondage of slavery in Egypt, He set a drumbeat of remembrance into the rhythms of the Law: "I am the LORD your God, who brought you out of Egypt."[26] Yahweh knew that it would be all too easy to forget that freedom was a miracle. It wouldn't be long before the wonder of liberation would be taken for granted. Before they even saw the promised land, the Israelites would bow down to a golden calf and claim that it brought the people out of Egypt![27]

NEVER FORGET WHERE YOU COME FROM, AND ALWAYS REMEMBER HOW FAR GOD HAS BROUGHT YOU.

Because He knew how easy it would be to forget the Giver, He wove the rhythm of remembrance into Passover, made it sensory so the people would taste the roast lamb, smell the aroma of the baking bread, and ingest the memory of liberation by God. He wove remembrance into the Sabbath, a day of rest to remind the people that provision comes from Yahweh and not just by human effort. Jesus provided the same for us: a communion meal to help us to remember His work on our behalf, to rest in the forgiveness and grace of God rather than boast of our own futile works toward righteousness.

We make music, proclaim speeches, create food and films, run fast, jump high, swim far, and declare each other great, as if God did not give us our abilities. God is the great one doing great things through the gifts He gives us. Truth be told, every award I have shouldn't have my name inscribed on it but should say, "To God, the giver of good gifts and the greatest talent of all." Remembering often that God gave us what we needed to grow us out of harmful situations, or to equip us to shine in our talents, keeps us from the snare of idolizing the gift instead of the Giver.

God's not a stingy giver, understand. God isn't salty about giving us gifts, but He's delighted to

receive the honor for them. I am not recommending you say a begrudging "thank You" to God like a little kid who just received a lump of coal for Christmas. I believe that there's freedom in knowing our talents and our futures aren't just dependent on us. There's a dance of communion between God and His people as we use, develop, and celebrate our gifts and simultaneously show sincere gratitude to our Benefactor.

THERE'S A DANCE OF COMMUNION BETWEEN GOD AND HIS PEOPLE.

So, what will you do with the gifts you've been so graciously given? How will you give thanks for the great things that God has equipped you to do?

Consider the transformative work of Jesus in your life. Maybe you can trace the line of God's abundance in your talents and skills. Maybe it's in the story He has written on your life so far—a story of rescue from addiction or a cycle of abuse. Maybe you can see His blessings in your relationships—the gift of a spouse, a child, a mentor, or a sibling. And for all of these things, we give God the glory.

How are you setting up rhythms of remembrance in your own life to celebrate all you've been blessed with? Is it communion? A meal? A fast? Your private worship hour in the morning? Don't just wait for Sunday morning. Make rhythms of gratitude constant in your day. And if you're like me, you might need a praise break for yourself as you recall all that He's brought you from and brought you through.

> **DON'T JUST WAIT FOR SUNDAY MORNING. MAKE RHYTHMS OF GRATITUDE CONSTANT IN YOUR DAY.**

LUCKY ME

Under the sun I found we were left to drown.
Evil abounds, the weight is pulling us down,
no sight or sound.

Impaired to His care
chasing after the wind, feasting to get full on the delicacies of air.

Deserving of desertion
we're servants of destruction,
and every day we taste of a grace that we're unconcerned with,
my sin I should've burned with.

I'm guilty, filthy, and stained
but He became My curse.

He drank my cup and took my pain
and for that He reigns.
Through faith I'm changed
and I don't have a reason why He loosened up my chains.

I don't believe in luck,
I believe in grace.

But they say we lucky cuz we seen Your face
and we heard Him call us
and You heard our answer
and You give second chances when we throw our hands up.

So weary and broken, hoping Your arms will open,
unconditional love has got us locked into focus.

You're greater than my shame, my guilt, my doubt, and my past.

Fortunate to trust in You
cuz I've doubted Your plans.

I've questioned Your ways.
Every question I've raised
is foolishness compared to mountains,
the wind, the waves
so mindful of us.

We rise from the dust.
You love these cheating, beating hearts and these eyes full of lust.

Gave us power to fight it
though we cower in quiet.
We have the faith to start a riot,
how can we deny it?

Fire inside us that You kindle when it starts to dwindle.
Simply put I'm sinful
so Your love is so essential.
We heard You call us
and You heard our answer
and give second chances when we throw our hands up
so weary and broken, hoping Your arms will open.
Unconditional love has got us locked into focus.

I don't believe in luck; I believe in grace. Sometimes the grace of God looks like not getting what we want, because we need to grow or heal. I believe the concept of luck takes the credit away from the strength of God in one's life. Circumstances are a complex weaving of the sovereignty of God and the choices of humanity. Luck exists only in the absence of an intentional, informed, and empathetic Creator. Luck is a simplistic catchall term for the mysterious, and it credits no one and nothing. I'm not feeling that. I've lived too long and been through too much to be standing here just because of dumb luck. God literally saved my life. And God is healing me.

In 2020, I desperately wanted a win. I crawled out of depression and attempted to write my way toward healing. I prayed to God after releasing my album *Restoration*—putting it out like Gideon put out his fleece[28]—and tested Him. *If this album does well*, I prayed, *then I will know that You love me.* I thought restoration should look like the same commercial, public success I experienced with *Anomaly*.

The album did fine. It wasn't bad. I was nominated for a Grammy. But disappointment overwhelmed me. I felt like my fleece was dry, but God didn't come through. I was looking to the numbers and likes for evidence of God's love, but God doesn't work like that.

I DON'T

BELIEVE

IN LUCK;

I BELIEVE

IN GRACE.

I always say, "You live for acceptance, you die from the rejection." I say that because that's my biggest struggle. And I was struggling.

"YOU LIVE FOR ACCEPTANCE, YOU DIE FROM THE REJECTION."

God's grace abounds. I felt impressed by Him to just look in front of me, instead of looking at world stages or Billboard charts. God began sharpening my focus to my community, to the well-being of children and unhoused people in my area. It's like the Scriptures impressed upon me, "Stop catering to the eye and start listening to and honoring the lesser-known parts."[29]

And then I started looking at my own family. My grandmother had twelve kids. We had stories of rifts, divorces, drugs, fighting, baby daddies, and baby mamas. We were scattered and lacking solidarity. My wife and I decided to pay the expenses to invite all my aunts and uncles over for Christmas at our house. Some of them hadn't gotten together in decades. We anointed the house with oil like the good

Pentebapticostals we are, and knelt in the living room, praying for the reconciliation and care that we hoped would be ushered in by the Spirit of God. Another fleece.

Seven of my eleven aunts and uncles accepted the invitation. My cousins heard and came to the house too.

I remember the defining moment of that Christmas—my wife and I went for a walk, and when we came back home, we stopped dead at our door to take in the answered prayer: my aunts and uncles were hugging and crying and confessing and reconciling. And they were standing in the very spot where my wife and I had prayed. My uncle Chris declared his sobriety that Christmas, and he's been clean ever since. We continue to be overwhelmed with gratitude.

This wasn't coincidence or luck but a bespoke blessing: God's answer to a little boy's desire to belong, to feel a part of a loving family all those years ago. God allowed me to make room for reconciliation in my family and gave me a peace I had been longing for. I can't pass through my living room without being reminded of God's attentive love.

My gracious God heard my prayers for both critical acclaim and the gathering of my family. I am free to be honest with God, even if the prayers are

problematic. I am learning to trust God's answers are best, even if they aren't what I would like. God's story arc is richer and often unexpected.

What happens in our lives is too intentional to be luck; it's the love of God. And I am so thankful to God that our "luck" doesn't run out when we express our emotions to God. Perfection is not a prerequisite to being heard.

I take my cue from the psalmists and the prophets in the Bible, who model what it looks like to be emotionally raw before God. Never holding back or faking how they feel. When we sit before the God of the universe, we are free to bring our rage, confusion, and doubt, and He can change them into peace, joy, and confidence. He may not change your circumstances, but He can change you. None of your doubts, your sin, or your emotions can get in the way. This isn't a lucky God. This is a sovereign God who wants good things for you. So relax. Bring your fleece. Pray. And when you do, trust that He will help you.

> **WHAT HAPPENS IN OUR LIVES IS TOO INTENTIONAL TO BE LUCK; IT'S THE LOVE OF GOD.**

GROCERY SHOPPING

Christ achieved victory through suffering.

We are victorious, holy, blameless, new creatures.

 Superheroes who don't know it.

Though we suffer we will reign. Though we sin we will still

 be rewarded.

Little kids trying to help in the grocery store.

Our strength is not needed but God delights to give us

 the privilege of working in His redemptive plan.

We dropped the jar of sauce. Cleanup on aisle 8.

Understanding that we are not needed should not make us lazy.

I live victoriously because He lives with me.

I die victoriously because I move toward Him in heaven.

I rise victoriously because I rise to live with Him.

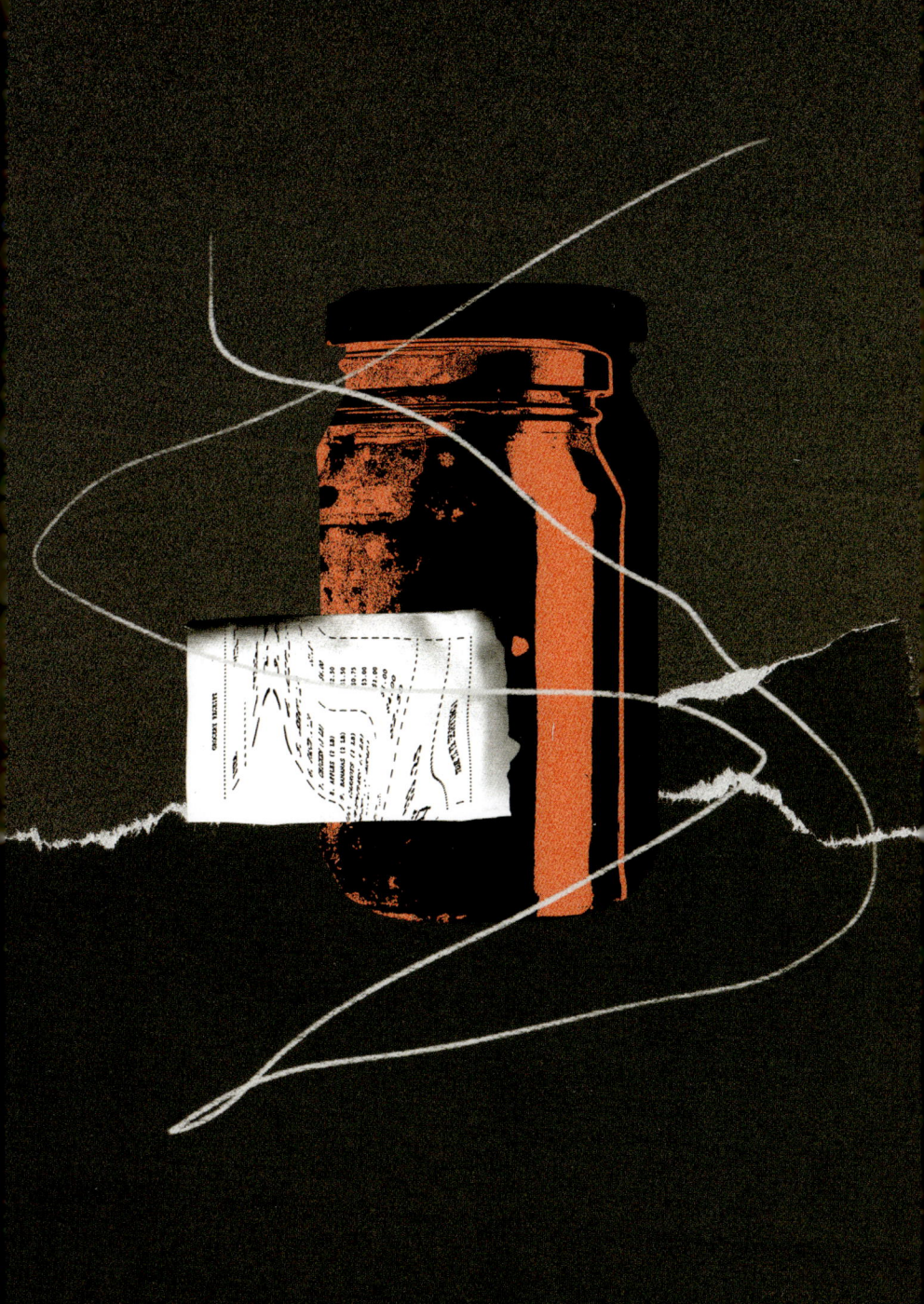

I remember taking my daughter grocery shopping when she was little. She pretended to read the grocery list but then asked me what each word meant—just to be sure. Her chubby legs swung to release some of her boundless energy. She grabbed at the sweet, colorful cereal boxes, cooed at the cookies, and almost jumped out of the cart when she saw the Pink Lady apples. Delayed gratification was a lesson she absolutely did not want to learn. I had been given parental advice that just saying no in response to a request was a bad idea. I know I am a professional wordsmith, but I was pressed to find synonyms: "Not right now," and "Let's wait until it's somebody's birthday to buy the birthday cake," and "Daddy will give you a prize if you keep your arms in the cart while we pass the doughnuts." And don't even get me started on how long it took to get items on the conveyer belt when my baby girl was in charge. We were there for-ev-er!

There were many grocery runs that had me second-guessing my choice to bring my young children food shopping with me. It would be faster without them. There would be far less drama. And if I decided to shop and snack on Cheetos at the same time, I wouldn't have to share. I don't need my children in order to shop, but there are so many benefits.

DELAYED GRATIFICATION WAS A LESSON SHE ABSOLUTELY DID NOT WANT TO LEARN.

We get to spend time together as we run errands, and any chance I get to connect with my children is a gift. They also started to learn essential things about life: they learned that the sugary treats they want to consume won't necessarily nourish them, so they should focus on both taste and nutritional value; budgets and lists are a way to ensure that they spend responsibly; and boy, did they learn that they simply cannot have everything—sometimes the answer really is no.

I am struck by our human limitations and God's eternal vastness. When you think about just how small we are compared to God, it is staggering. One of the closest stars in our universe makes the sun look like a grain of salt, the earth invisible, and humanity an absolute speck in comparison. God created all of these. God is uncontainable, and we are infinitesimal. And yet He is God With Us. We are so privileged. He is the God who sees the downcast and is close to the brokenhearted, who counts sparrows and knows the number of hairs on our heads. He is the Father who delights in me and in you, who, when you were formed, said, "You are good."

Sometimes I think of us believers, the children of God, as the little kids in the cart. Just as parents do not need their children's help to pick produce, God

does not *need* our help bringing about His plan. He doesn't need us, but He wants to stay close because He loves us. And in the course of life, even in mundane moments, God can teach us something about the nature of His love.

God is sharing with us in His all-sufficiency. We are powerless, but we receive power to know Him and to do good works through the Holy Spirit. We hold within us this treasure, the Counselor who helps us to recall the Word of God and directs us toward our next steps. We have an Advocate in Jesus, who was tempted in every way yet without sin—so we can be confident that He knows exactly how to intercede on our behalf when we're weak or tempted or just tired. Death is hard on all our heels, but through Jesus, death does not get the last word. Life is sometimes beautiful, sometimes a beating, and oftentimes both, but we have peace with the Father; we are beloved, and because God is with us, we don't go through trials alone.

With God pushing the cart, so to speak, we don't want for anything. We have everything we need for life and godliness. And most of all, we have God's presence and nearness.

It's not just about fulfilling a task with the Father. It's time spent. It's closeness.

LIFE IS SOMETIMES BEAUTIFUL, SOMETIMES A BEATING, AND OFTENTIMES BOTH.

THE TOMB IS EMPTY

When Adam and Eve tasted death
There was always a plan for God to crush the serpent,
A plan for life to come back forever.

When Moses after killing returned to face the fierce power of Pharoah
He trusted in a plan for God to empty the land of his people.

When Israel walked through the desert for years in wandering, sickness, pain, and death
They believed God would empty the sky and rain manna from heaven.

When David sinned by stealing a bride and killing the husband at her side
He believed God would empty His cup of mercy upon him.

When Christ walked to His death
He knew God's cup of anger would be poured out on Him.

But something happened. In three days the tomb was empty, and the prophecy had come to pass.
Death and all his evil companions were defeated.

When they walked the trail of tears, when Black children were sold as slaves, when Jewish mothers cried in hiding,

I can't make sense of it, but I know the tomb was empty.

When it feels like evil has won,
the tomb is empty.

It was empty then and it's empty now.
There is where my hope resides.

here does hope lie? Where can hope be found? Turns out, hope is in an empty space.

In 2019 I worked hard to outrun depression, pursue therapy, seek the Lord, join a church, and repair my relationship with my wife. There was also a constant hum of desperation within me—I wondered when the Lord would heal me, whether I was doing enough on my own for God to intervene and have mercy. I developed an acute anxiety disorder that I manage to this day. Looking back, I know I was fighting to leave the unhealthy dependencies I had developed. I didn't want to lean on drugs and I knew better than to deny God anymore, but I also felt exhausted from striving. The same way I would try to please my audiences or the public, I was trying to do enough to please God so that God would move.

When God didn't move the way I had hoped, I thought I would move toward God. My wife and a group of friends and I had the opportunity to take a tour of Israel and jumped at the chance. One of my wife's friends was giving me a side-eye the entire time, thinking we were embarking on an awfully elaborate trip just to keep up appearances and snap pics for the 'gram. She was justified: she supported my wife after I revealed to her that I was out in the clubs popping

WHEN GOD DIDN'T MOVE THE WAY I HAD HOPED, I THOUGHT I WOULD MOVE TOWARD GOD.

benzos and drinking while on tour. All I could do was take the dirty looks and thank God my wife had a friend who wanted to protect her. All I could do was make the choice every day to be the man who my wife deserved—trustworthy, repentant, loving, considerate. I really had no leg to stand on. I was flying to Israel to find God, to find hope.

I think of Moses, entreating God to be present for him and all the people so that they could cross safely into the promised land. God was frustrated with the stubbornness of the Israelites and restrained Himself from just starting over with Moses alone. In Exodus 33, God relented and said He'd be present for the people. Then Moses asked, "Now show me Your glory." God said, "You can't see My face and live," but hid Moses in a rock cleft and showed him His back.[30]

I wanted God to show me His glory.

We saw where Moses led the people. We saw the place where Jesus taught, and where He was baptized. And then we got to the garden tomb. It was empty. This is God's glory: that through Jesus, the Israelites did behold God's face and lived. This is God's glory: that Jesus's face, His body, cannot be found buried within any rock, because He has risen. And this is my hope: resurrections of relationships, purpose, and trust can still happen in my life—our lives—because

I WANTED GOD TO SHOW ME HIS GLORY.

Jesus has already defeated death. He has set us free. And He is God Still With Us. Yahweh answered Moses's prayer with Jesus.

We wept tears of joy and prayed and worshiped at that empty tomb. Amazingly, my wife's friend and I reconciled right there at the tomb. I commemorated the hope I found with a mikvah in the Jordan River. And because we Black and we out here, we did the wobble on a boat cruise on the Sea of Galilee. The empty tomb is worthy of a praise dance!

> **AND BECAUSE WE BLACK AND WE OUT HERE, WE DID THE WOBBLE ON A BOAT CRUISE ON THE SEA OF GALILEE.**

I stay in awe of the fact that the Second Person of the Trinity decided to know and forevermore inhabit the vulnerability of humanity. He grew in the womb of a young woman. He learned to walk, talk, and love other people as a man. He learned the hardships of the people in His community and lived as a Jewish

man in a territory occupied by Romans. Life for Him was no crystal stair. He knows what it is to live here.

The suffering of Yeshua is also a preview for us. The ridicule, the rejection, the abandonment, the injustices, the humiliation—Jesus endured them all. Yeshua was willing to sacrifice His life on our behalf. He understands our lives and He is well acquainted with death.

Yeshua's life, death, and resurrection are a preview for us. His triumph over death is the first of many resurrection Sunday experiences to come. I believe that death is not the end, because of the resurrection, and that because of Christ's work, there is an eternal future where my broken body will be made wholly alive.

You might be struggling now—I still struggle with anxiety; I wasn't miraculously healed in Israel. But rest in reality that the tomb is empty. Freedom is here, and freedom will come. It may not come while we're here. But it's coming. And we ought to fight for freedom while we're here. Freedom is pushing for the liberation of heaven, here, because that's the picture of the kingdom: "Thy kingdom come, Thy will be done in earth, as it is in heaven."[31]

DEATH IS NOT THE END.

WE OUGHT TO

FIGHT FOR FREEDOM

WHILE WE'RE HERE.

...s are swe...
...of the...y...
...Our...br...
...ecau...ur...
...ds. rts...
SEE YOU LATER
...of y...
...adership. We...
...touched...

Our lives are sweeter because of the time you gave us.

Our days are brighter because of your wise words.

Our hearts are stronger because of your great leadership.

We know you touched many lives, but you shaped ours.

We will miss you for a season, but we are

confident and excited to see you in heaven.

We do not grieve as those who have no hope.

Hope lives in the shadow of death. In the spaces of doubt and grief, hope grows like a blade of grass tunneling out of cracked concrete. Sometimes we talk about hope in sanitized, cheerful terms and place it in a tidy bouquet between faith and love. But that's not where hope lives, really.

Hope is projecting future peace into a violent now. It scoops up the blood and flesh of dying dreams and whispers, "Behold, I will make all things new." Hope doesn't look away when death approaches, because it knows of stronger things than death. Hope takes the pain inflicted upon it and may collapse, but then gets back up.

The empty tomb of Jesus does *not* mean our tears and pain are not valid.

It feels like, though Jesus is alive and *His* stone was rolled away on resurrection Sunday, we still languish in a perpetual Saturday of disease, war, injustice, famine, and oppression. Death is a certainty, and there's nothing like death to remind us that we are absolutely fragile.

My father-in-law was the first man in my life to tell me he was proud of me. He encouraged me to continue loving my mother-in-law and my wife with such care and provision. I miss him so much. He died a painful death from cancer. I watched him change

HOPE LIVES

IN THE

SHADOW OF

DEATH.

from being a muscular man with a kind smile to a shell of a person, constantly wincing in pain. I know he would have preferred to be healed; we all would have chosen that. I am not going to lie to you and say that cancer is good or death is good—if it were, why would Jesus have come to defeat it?

Julius, my cousin, was like my twin; our birthdays were three days apart. We went through everything together. But our world treated us differently; he did what he needed to do to provide and got snatched by prison and addiction. When I look at people struggling with addiction or incarceration, I see Julius. I see people who are so loved. Julius loved Jesus—I think that's how he got the strength to fight his demons for so long. One day, Julius was in rehab quoting James Baldwin, the next he was dead from an overdose. I know as much as I can know about what happens when we die, but one thing I do know: he's with Jesus.

My father-in-law and my cousin understood something more about Jesus because of what they endured. "We share in his sufferings in order that we may also share in his glory."[32] This is the truth revealed through baptism: we can expect to die in order to live again. Sometimes the cycle of death and life is metaphorical, taking place in the context of

relationships or plans, and sometimes it is enacted through our very bodies.

The gospel—good news—has so much depth that we miss when we wrongly expect belief in Jesus to shield us from horrible things ever happening to us. "In this life, you will have trouble,"[33] Jesus guaranteed. Jesus, who was mocked, spat upon, beaten, and nailed to a cross despite committing no crime, assured His followers that suffering would occur in this broken world.

SOMETIMES THE CYCLE OF DEATH AND LIFE IS METAPHORICAL.

Live long enough, and the grief of death will come to you. Death is the world's worst constant. You might hear some people talk about death as if it's a wonderful vacation from the woes of this world, or that God enjoys taking people out. There's a lot of insufficient popular theology about death—my charitable take is that folks mean well and want to calm the sting.

As Christians, we have a hope that lies in the shadow of death. This isn't a trivializing of death but a reminder that death is not the end, and that reunion

will come. For those of us who have the hope of Christ, it is definitely "see you later," never "goodbye" for good. It's not an easy, shallow hope, though. It's tested through watching loved ones suffer debilitating sickness, the shock of unexpected passing, the heartache of an empty seat at the dinner table. The seed of this hope is often watered by tears as we commend our loved ones to God. This hope must be robust enough to endure the reality that our happy reunion with deceased loved ones could happen because we pass through death's door ourselves, if the Lord chooses to delay His return.

AS CHRISTIANS, WE HAVE A HOPE THAT LIES IN THE SHADOW OF DEATH.

If you are in a place of mourning someone you cared about right now, I'm sorry: I am sorry that that coward Death has visited and taken from you. I am sorry for the heartache, the unanswered questions, the shock, the surprising anger, the confusion. I hope that you are free to grieve without anyone offering impotent platitudes to help them, not you, feel more comfortable. I pray that you have the space to grieve

honestly. In the days to come, I hope that you find solace in the memory of your loved one, blanketing yourself with their wisdom and humor, the sound of their laughter, their scent when you hugged them, the texture of their hair, and the glint in their eyes. The memory of them is your inheritance, for now. Until you meet again.

SMOKE ON MY CLOTHES

I'm not ashamed of pain,
not ashamed of my struggle.
I lost battles but I'm still out here facing the trouble.

Facing my trials because they only make ya stronger,
starving in the streets only elevates ya hunger.

Beat me down and laugh at me,
tell me this is foolishness.
They can't take my hope away from me, nobody's moving it.

Faith ain't what you make it,
faith is all I got to make it.

You doubt it or you forsake it
and you're left feeling vacant

Forget all the naysayers
the haters
and stay at it.
Sometimes a dream broken is a dream worth having.

My passions are passing my past up.
I can't rewind it or back up.

My focus is fixed on the future
so, tell my failures to back up.

Get back up after you fall
when your back is up on the wall
no backup that you can call.

Just look back up at God.
Sometimes the pain is the motivation to trust
the scars are evidence that our journey was enough.

Darkest days, darkest hours
less than nothing left with no power.
I cower so rightfully they call me coward.

They bully you
breed you out
wipe they feet on you while using your clout.
Trying to stand tall but no backbone to hold me so I am not feeling stout.

I danced with the lies that asked me for a round.
Negated the worth that of honor and glory that dawns my crown.

My brain needs calibration,
My vein got me feeling in vain as they need liberation.

My scope got zeroed in so the target is clear.
I am only hitting bull's-eyes, my training is no fear.

Gain means endure,
struggle means secure.

You cannot give what was given before the world.
No longer unfaithful I stopped sleeping with the world.

Bring the speech,
Bring the heat.

My God and I walking in the furnace,
My hair won't get singed, His plans keep earnest.

Be amazed at my God who needs no defense.
He stepped down and took it all so what I go through is the least of it.

So come close.
You may smell smoke on my clothes.

Part of being a Christian means you're walking away from something in order to follow Jesus. You're walking away from the pursuit of selfish gain. You're walking away from viewing your life and your body as your own personal kingdom. You're walking away from old perspectives of power built on scarcity and hierarchy. For me, committing myself to following Jesus looked like walking away from toxic masculinity that ignored my ache for love and approval; walking away from follower counts as a measure of success; even walking away from weed—the original smoke on my clothes!

Following the Good Shepherd isn't all green pastures and refreshing waters. Sometimes faithfulness to God leads us to the deep, dark valleys. When I walked through the deep, dark valley of rejection, I thought my career might be over. I wrestled with what it meant that the more myself I became, the more rejection I experienced. Now I reflect on how there's nothing new under the sun: the story of Moses has similar parallels. Moses was an undercover Jew living in Pharaoh's house. He adapted to the ways of Egyptian royalty. He adapted again to the pastoral life of a shepherd in Midian. When the Lord drew him back to his origins, he needed to lean on every bit of his identity to stand before both Pharaoh and the

WE CAN MOVE FORWARD UNASHAMED OF THE SCENT OF OUR PASTS.

Israelites—and though he stood squarely within the will of God, he experienced rejection from all sides. Again—I am no Moses, but I take solace in the way he needed every bit of his past to inform his leadership in the future. I take solace in the fact that he had smoke on his clothes, so to speak, from his people's oppression, Pharaoh's house, and Midian.

Part of being a Christian also means we're going to walk through trials. But in Christ, we can trust that we will come out the other side, refined.

Too often we fear the flames of trials, and we recoil or give way in the face of trials. *Smoke on my clothes* is also an ode to the three Hebrew boys of Daniel 3—Shadrach, Meshach, and Abednego—who stayed true to God, even as literal fiery flames roared around them. These three scholars were kidnapped by the armies of Babylon, living in exile under King Nebuchadnezzar. They were given a choice: bow down to the image of the king of Babylon or be sentenced to die in a fiery furnace. They chose the fire.

SPEAK OUT ON OPPRESSION. SPEAK UP FOR THE SIDELINED NEIGHBORS. USE YOUR VOICE AND THE SYSTEMS AVAILABLE TO YOU TO MAKE SOME CHANGE.

Imagine the faith of these young Hebrew men, to resist the empire and stake their lives on the goodness of God, even if it meant death! The God of all comfort comforted those young men and protected them in the furnace. And they walked out of there with the smoky aroma of Yahweh.

I have been guilty of fearing the furnace, and I daily war to stay encouraged in my faith, especially when I think it may burn a little. I'll be honest—sometimes it's hard to believe that an invisible God is truer and better than the physical path laid before me. But when we put our faith in God and act according to His good and perfect call on our lives, we get to experience His unwavering presence in a radical way. With Jesus on our side, we can stand in the furnace while it's at its hottest, and the only thing we smell is smoke on our clothes.

Staying true to God may mean civil disobedience. It's pretty unlikely that you're going to be faced with a literal furnace. But you may be presented with a similar trial someday, where you are asked to get in line to jeopardize your beliefs or choose to stand up for God.

The modern-day, smoke-on-his-clothes person who comes to mind for me is Bryan Stevenson, lawyer and tireless advocate for people who are on death row. Stevenson founded the Equal Justice Initiative in order to bring equity and justice to the criminal legal system.

WE CAN STAND IN THE FURNACE WHILE IT'S AT ITS HOTTEST.

Even after constantly fighting systems entrenched in callousness and oppression, he said that "hopelessness is the enemy of justice."[34] He clings to hope with an otherworldly sense of assurance. This is a man who chooses the fire. I was honored to meet Bryan when I was graciously invited by Nona Jones to speak at AfroTech (a door God opened for me to be a voice in spaces I couldn't imagine, just when I thought rejection was my only portion). I am grateful I got to thank him for impacting my life by fleshing out his faith with courageous action, against all kinds of adversarial circumstances.

We can move forward unashamed of the scent of our pasts. It reminds us of what we've made it through. Let's walk with the fiery assurance of Bryan, that godly swagger of Shadrach, Meshach, and Abednego. Speak out on oppression. Speak up for the sidelined neighbors. Use your voice and the systems available to you to make some change. Choose the fire. You may suffer for it. Or be mocked for it. But you're also going to experience the palpable presence of God in the middle of that opposition. God's going to draw near to you, in ways you haven't yet experienced, and He will shore you up and keep you close during trying times. *Don't* be afraid to go through the fire; your God is there with you, He has been through it and will bring you through.

> **STAYING TRUE TO GOD MAY MEAN CIVIL DISOBEDIENCE.**

I'm Frederick Douglass,
I'm on my Frederick
 Douglass.

They promised me
 my freedom
if I snitch on all
 my cousins.
They give a couple
 million for a song
 about killin'
but they really just
 investing in they
 private prison pension.

Listen.
I gave Chief Keef my
 number in New York
 this summer,
told him I can get
 you free, I'm on
 my Nat Turner.

I'm on my Harriet, bury
 me next to Honest Abe.
Here lies another man
 they killed for tryna
 free the slaves.

Let them chains go
or Imma have to act
 out Django.
I swear they gon have
 to put me down to
 keep me from tryna
 change folks.

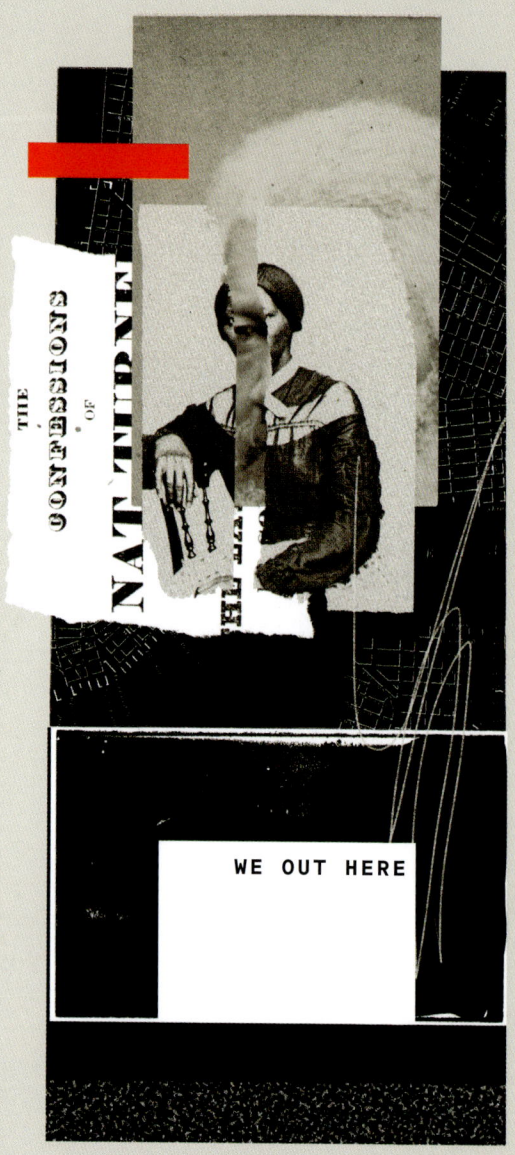

Yep
I'm on a mission, this ain't organized religion.
Who gon stop us?
Who gon block us?
Get yo chop pas, get yo prisons,
they can lock us up and kill us.

Keep us outta the mirrors reflecting God's image.
Our destiny lookin' clearer.

I see a vicious cycle that's sweeping up all the children.
The devil steady tryin' to conceal it.
It's time to get free cuz Jesus died and He'll be back,
so tell me what can trump that.
I rather die for my faith than live for things I can't take.

Who gwan stop I?
Who gwan block I?
We seen the cross, the holocaust, and been through apartheid.
Been locked up.
We everywhere and they never there
we never scarred and we unashamed
and tell em getcha umbrellas ready, Jesus reigns.

Cuz I don't pretend I live this,
and some folks on the fences.

And that girl you took home last night she swore she was a Christian,
Well, she might be and likely she like you and just like me,
an imperfect person broke and hurtin' tryna do the right thing.

That bad one that's wifey you know she 'bout that life B.
She got red bottoms you ain't never seen.
Her soul's covered up nicely,
that's blood dipped,
I mean blood bought
no sowoo
but this blood talk.
But don't be shocked to see us in here rappin' in the club, bruh.

If there were a sale on Js, I would tell everyone about them (after I got my pairs in my sizes, ha ha!), because a sale on Jordans is something everybody ought to know about. It's a good deal.

When we get good news, we can't help but share it. We want to tell everybody every little detail with all the excitement and energy we have. It's good will, and we're passing it on.

In a similar way, I am compelled to let people know that Jesus is good news. He is the King of peace, who takes people as they are and welcomes them as citizens. No border patrol fences or agents on horseback with whips in this land. This good King says to the weary, "I will give you rest." He does not exploit the poor, and He doesn't hoard riches. Women are safe with this King; He does not use His powers to assault and cover up, but to edify and to lift up. He abolishes guilt and shame from the hearts of His citizens and offers purpose and passion—the good works and rest and worship that they were created uniquely for. I cannot be stopped from letting anyone know about this love offering—the news is too good.

Good news *for* all isn't good news *to* all, sadly. Some people will try to block the spread of God's love because they want a false kingdom—ruled by

WHEN WE GET GOOD NEWS, WE CAN'T HELP BUT SHARE IT.

deception, misinformation, temptation, and the ego. This is the kingdom of the accuser, who always stands ready to convince people that they are worthless. The only way to freedom, according to this false kingdom, is through greed—beat everyone else to the resources, the talent, the beauty, the power, and accumulate and hoard it. You don't have to look far to see this false kingdom. It's advertising to us all the time about the Instagrammable lives we could lead if we just had that spouse, those muscles, that figure, that bank account, those clothes, those friends, that mansion, and those politicians in our pockets. The false kingdom feeds on an insatiable compulsion to consume.

But what does it profit people to gain the whole world and lose their soul?

The false kingdom is deceitfully self-centered—it never thinks of legacy and never speaks of death. This kingdom wants us so bent on accumulation that we forget our pricelessness—forget that we are made in God's image, loved and pursued by God, and welcomed in His presence. All-access VIP. Better than any red carpet and more valid than a blue check. You, reading this: Your existence is a miracle that cannot be quantified. Jesus invites you to rest from striving, and that's good news.

BUT WHAT DOES IT PROFIT PEOPLE TO GAIN THE WHOLE WORLD AND LOSE THEIR SOUL?

The prophet speaks to this in Isaiah 55:

> "Come, all you who are thirsty,
> come to the waters;
> and you who have no money,
> come, buy and eat!
> Come, buy wine and milk
> without money and without cost.
> Why spend money on what is not
> bread,
> and your labor on what does not
> satisfy?
> Listen, listen to me, and eat what
> is good,
> and you will delight in the richest
> of fare."[35]

Jesus's kingdom is free from striving, because it's a place where power is shared. Think about it: Whenever Jesus is given power and authority, what does He do with it? He disperses it and blesses His followers and declares that they will do greater things. He commissions His followers to go and make disciples. He promises the Spirit to guide and empower them. Jesus raises up the people society ignores—fishermen and tax collectors and

the formerly demon-possessed, and the women He teaches people who would be discounted by society—and says, "These people represent Me. These are My witnesses." He empowers. The founding of the church occured through the power of the Spirit working through Jews and Gentiles, who gathered in Jesus's name, confounding society with their togetherness. The kingdom of God looks like dignity and empowerment, especially those of us too ashamed to feel like we deserve it. That's good news.

The laying down of a scarcity mindset in favor of cooperative abundance speaks to our souls, because it's a better vision than the greed of the false kingdom.

I'm inspired by my ancestors who were dedicated to an embodied, collective freedom—soul and body. Nat Turner gave his life rebelling against chattel slavery, all in the name of preserving the dignity of every man and woman who looked like him. Harriet Tubman was a Moses figure to so many people, mirroring the emancipating love of God as she led people north to freedom. Their legacies loomed larger than just their lives, their pockets, their bellies. They were intent on setting people free. They wagered their own lives for the freedom of others.

Righteousness brings an energy that greed and

selfishness never could, an endurance that may ebb but won't be defeated. We out here! We out here! They can beat us, mock us, try to cancel us, bury us, kill us, but we are out here. We are of that line that refuses to let the ridicule keep us quiet.

Our enthusiasm for the good news can become a witness for our King that the gates of hell cannot defeat. A life dedicated to justice and love is an infectious witness, and that life's influence continues for generations.

> **RIGHTEOUSNESS BRINGS AN ENERGY THAT GREED AND SELFISHNESS NEVER COULD.**

FREEDOM _ YOU
NEED TO EXPLAIN
PAIN, YOUR SUF-
OF YOUR COLONIZA-
IMPRISONMENT.
YOU ARE FREE. /
/ YOU ARE A CO-

ARE FEELING THE

YOURSELF, YOUR

FERING AS A RESULT

TION AND SOCIAL

/ DECOLONIZE. /

YOU ARE LOVED.

HEIR WITH CHRIST.

My great-great-grandmother Alia was born into slavery in Texas, the same state where Jesus found me in a college dorm. She was freed on Juneteenth. So of course Juneteenth had way more meaning to us than the Fourth of July did. The Fourth of July did not mean Grandma Alia was free. Juneteenth did. There's a joy in knowing when freedom actually happened versus when we're told we're all supposed to celebrate freedom.

Freedom in Christ hits different when we know we are beloved. When we know that when we stray, we have a Shepherd who will look for us. When we know that our context or color or country doesn't determine our worth to God; we were born worthy. We have a hollow idea of freedom peddled here in the United States. It will never make sense to me that the country founded on the slaughter and displacement of indigenous peoples, that profited from the free, forced labor of Black people for centuries, and is the most carceral nation in the developed world, could boast of being the "land of the free." *Freedom* is too sacred a word to be so constantly abused and misappropriated. Free for whom? Free to do what? There are people in this country who are even now banning books that describe the atrocities the United States has committed. Mass delusion is not a good look. As long as some

THE FOURTH OF JULY

DID NOT MEAN GRANDMA

ALIA WAS FREE.

JUNETEENTH DID.

of my American siblings choose willful blindness over contrition and repair, this country can never be the land of the free.

We are citizens of another kingdom, though—glory to God. In Christ, we are not sheep without a shepherd—we have hope, right now. Freedom is our inheritance. This freedom is a deeply spiritual concept, but it's also flesh and blood. It's a journey of faith, and also one of intentional action. The incarnation of Jesus Christ brings honor to the experience of our bodies, because in Christ, the body and spirit, the Word and flesh exist in unity and harmony. The incarnation reminds us that bodies are good, worthy of protection, compassion, and salvation. This is so essential for those of us who are constantly told that our bodies don't matter. No—Jesus died to rescue our bodies. He lives to redeem our bodies as well as our souls.

Freedom is not neutral in the face of injustice—it picks the side of dignity and flourishing. Freedom is not compatible with a spirituality that separates the Black soul from the Black body, claiming care for one while consistently showing disdain for the other. To be like Christ is to care for both soul and body. Whole life matters.

Freedom is available to all of us when we tear down our idols, confess our sins, depend on the mercy

and guidance of the Spirit, and repair the rifts we have caused with our neighbors. Freedom is available to us when we look in the mirror of God's love for us, rather than the distorted images fed to us by a culture of greed and caste.

Jesus taught us to pray for God's will to be done on earth as in heaven, and because of the flesh-and-blood life and testimony of the Second Person of the Trinity, we know that God's will is restoration, healing, and voluntary and exuberant worship in spirit and in truth—today. Jesus's birth, life, and ministry on earth remind us of God's commitment to us in the here and now, and not just in the sweet by-and-by. Here. Now. We can pray about it, and we can be about it.

WE DON'T HAVE TO WAIT TO DIE AND GO TO HEAVEN TO EXPERIENCE THIS FREEDOM.

We don't have to wait to die and go to heaven to experience this freedom. I believe God has given us, in Christ, through the power of the Spirit, the power

to walk with God without chains, and the keys to set other people free.

Set Me Free is my best attempt to urge you to walk in the freedom that God has already given you by observing, inquiring, and remembering who you are because of who God is. I am on a quest to claim the freedom that's mine as well. I certainly haven't arrived yet.

I hope that you can keep coming back to these poems and essays and examine the ideas and beliefs that hold you captive. You can freely worship God—even in the wilderness—and thrive without the strain of oppression. God didn't create us to be enslaved but to bear His image, abide with, and follow Him.

GOD DIDN'T CREATE US TO BE ENSLAVED BUT TO BEAR HIS IMAGE, ABIDE WITH, AND FOLLOW HIM.

NOTES

1. "Where the Spirit of the Lord *is*, there *is* liberty" (2 Corinthians 3:17 NKJV).

2. In the Hebrew Bible, Sheol is the underworld, similar to the Greek Hades. Adam Volle, last updated March 14, 2024, Britannica, https://www.britannica.com/topic/sheol.

3. Toni Morrison, *Song of Solomon* (New York, NY: Vintage Books, 2004), 179, symbols are author's modification.

4. Matthew 3:6.

5. 2 Kings 5:10–14.

6. This ain't her real name.

7. "Middle Passage," last updated March 29, 2024, Britannica, https://www.britannica.com/topic/Middle-Passage-slave-trade.

8. John 21:15 NKJV.

9. "Lynching in America: Targeting Black Veterans," Equal Justice Initiative, site accessed April 10, 2024, https://eji.org/wp-content/uploads/2019/10/lynching-in-america-targeting-black-veterans-web.pdf.

10. Langston Hughes, "A Dream Deferred," *Montage of a Dream Deferred* (New York: Holt, 1951).

11. "What does the Lord require of you? To act justly and to love mercy and to walk humbly with your God" (Micah 6:8, adapted).

12. G. D. Taylor (2014). *Testimony*, eds. D. Mangum, D. R. Brown, R. Klippenstein & and R. Hurst, *Lexham Theological Wordbook* (Bellingham, WA: Lexham Press, 2014).

13. "It was necessary to keep our religious masters at St. Michael's unacquainted with the fact, that, instead of spending the Sabbath in wrestling, boxing, and drinking whisky, we were trying to learn how to read the will of God; for they had much rather see us engaged in those degrading sports, than to see us behaving like intellectual, moral, and accountable beings." Frederick Douglass, *Narrative of the Life of Frederick Douglass, an American Slave* (New York, NY: Barnes & Noble, 2003), 75.

14. A ring shout went this way: "Participants moved in a circle, providing rhythm by clapping their hands and patting their feet. One individual would set the tempo by singing, and his lines would be answered in call-and-response fashion." Dakota Pippins, "Ring Shout," The Jazz

History Tree, https://www.jazzhistorytree.com/ring-shout.

15. "Christena Cleveland, a professor of reconciliation at Duke University, said that Lecrae is a kind of 'mascot' for white evangelicals—someone who is let in but not to play a serious role. 'The same students who play Lecrae in their dorms are the same ones protesting Black Lives Matter,' she said. 'Somehow in their minds they're able to separate it.'" Michelle Boorstein, "This Rapper Is Trying Hard to Get His Fellow Evangelicals to Talk About Race. Not Everyone Is on Board," *The Washington Post*, July 1, 2016, https://www.washingtonpost.com.

16. Bureau of Justice Statistics, accessed April 10, 2024, https://bjs.ojp.gov.

17. "That same day Pharaoh gave this order to the slave drivers and overseers in charge of the people: 'You are no longer to supply the people with straw for making bricks; let them go and gather their own straw. But require them to make the same number of bricks as before; don't reduce the quota. They are lazy; that is why they are crying out, "Let us go and sacrifice to our God." Make the work

harder for the people so that they keep working and pay no attention to lies'" (Exodus 5:6–9; see also vv. 15–17).

18. Deuteronomy 5:15, adapted.

19. Brian Stelter, "With 'Son of a Bitch'" Comments, Trump Tried to Divide NFL and Its Players," CNN Business, September 23, 2017, https://money.cnn.com.

20. Deena Zaru, "NFL Apologizes for 'Not Listening' to Players About Racism as Colin Kaepernick Remains Unsigned," ABC News, June 7, 2020, https://abcnews.go.com/US/nfl-apologizes-listening-players-racism-colin-kaepernick-remains/story?id=71122596.

21. Isaiah 1:17, adapted.

22. See Genesis 18:12–15.

23. See Genesis 27:1–41.

24. Exodus 12:35–36.

25. Exodus 20:2.

26. See Exodus 32.

27. Judges 6:36–40.

28. 1 Corinthians 12:21–26, adapted.

29. Exodus 33:18–23, adapted.

30. Matthew 6:10 KJV.

31. Romans 8:17.

32. John 16:33, adapted.

33. Josh Idaszak, "'Just Mercy' Author Bryan Stevenson Tells Wellesley Audience Hopelessness Is the Enemy of Justice," Wellesley College, May 3, 2022, https://www.wellesley.edu/news/just-mercy-author-bryan-stevenson-tells-wellesley-audience-hopelessness-is-the-enemy-of-justice.

34. Isaiah 55:1-2.

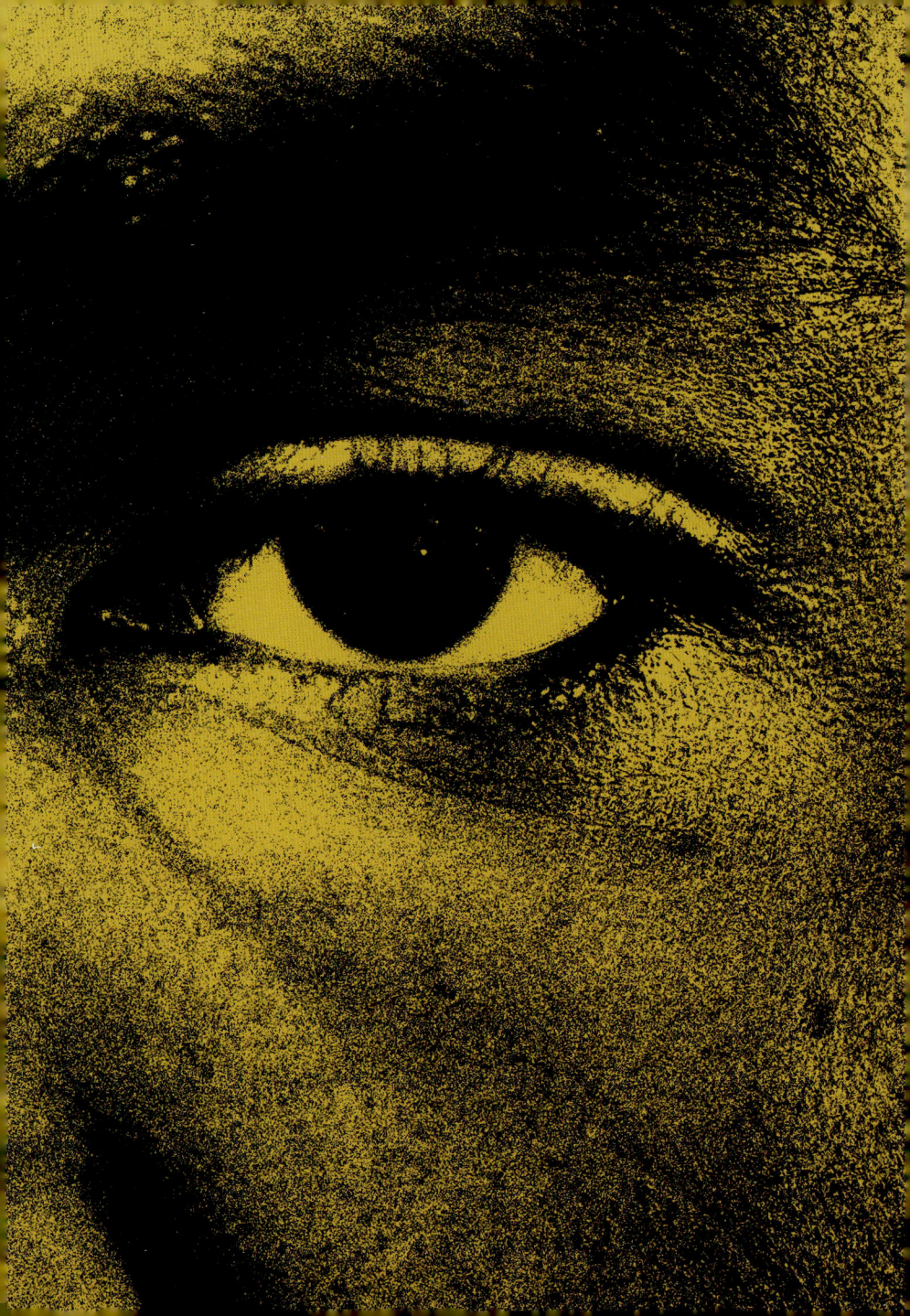

ABOUT THE AUTHOR

Multi Grammy Award–winning rap artist Lecrae has left an indelible mark in the world of music and entertainment. His music explores universal topics that bind, challenging industry norms with his faith-based rhyming style. He emerged in 2004 with the release of his debut album, *Real Talk*, and launched his own label, Reach Records. Not only has the perennial superstar proved to be a gospel success, but he's also crossed over into hip-hop and used his platform to foster a global fanbase. He's remained consistent and relevant throughout the 2000s, proven repeatedly with groundbreaking albums such as *Rebel* (2008), which made history as the first Christian hip-hop album to reach No. 1 on Billboard's Top Gospel Albums chart; *Gravity* (2012), netting his first career Grammy; and *Anomaly* (2017), the first Christian rap album to go gold. The last song on *Anomaly*, titled "Messengers" with for KING & COUNTRY, earned Lecrae his second Grammy win (for Best Contemporary Christian Music Performance/Song) at the 57th Grammy Awards. The LP also earned him his first No. 1 album on the Billboard 200.

The year 2022 was highlighted by the arrival of *Church Clothes 4*, and the deluxe version, *Church Clothes 4: Dry Clean Only*, arrived in 2023—thus symbolizing the end of Lecrae's popular mixtape series. In 2024,

About the Author

Lecrae started off the year by adding two more Grammys under his belt: one for his *Church Clothes 4* project (Best Contemporary Christian Music Album) and the other for his "Your Power" collaboration with Tasha Cobbs (Best Contemporary Christian Music Performance/Song). Over the years, Lecrae has garnered many awards and accolades, including four Grammy wins, two chart-topping gospel albums, a gold and platinum certification, and countless honors.

Beyond the music, Lecrae's prestige has grown considerably. He's a *New York Times* bestselling author, using writing and activism to inspire local communities. The latter is exemplified in his philanthropic work to help instill hope in incarcerated individuals and bring attention to mass incarceration. This has proven to be a recurring theme in Lecrae's previous partnerships with several nonprofit organizations such as Love Beyond Walls, Prison Fellowship, and Send Musicians to Prison on similar initiatives.

As a record executive, Lecrae has provided a pathway for artists who share his ethos—all of whom are signed to his Reach Records imprint. Simultaneously, he remains a pillar of the culture at large, infiltrating the podcasting community with his show, *The Deep End with Lecrae*. Throughout his career, Lecrae continues to be a voice for positive change, and his work amplifies his impact.